REZA WAR+PEACE

I said what about my eyes?

 "Keep them on the road."

I said what about my passion?

 "Keep it burning."

I said what about my heart?

 "Tell me what you hold inside it?"

I said pain and sorrow.

 He said: "Stay with it."

— RUMI (1207-1273)

Of one Essence is the human Race,

Thusly has Creation put the Base;

One Limb impacted is sufficient,

For all Others to feel the Mace.

— SA'ADI (1184-1283)

In generosity and helping others

Be like a river

In compassion and grace

Be like sun

In concealing others' faults

Be like night

In anger and fury

Be like dead

In modesty and humility

Be like earth

In tolerance

Be like a sea

Either exist as you are

Or be as you look

— RUMI (1207-1273)

Never do anything against conscience,

even if the state demands it.

— ALBERT EINSTEIN

If we are to teach real peace

in this world,

and if we are to carry on

a real war against war,

we shall have to begin

with the children.

— **MOHANDAS GANDHI**

REZA WAR+PEACE

A PHOTOGRAPHER'S JOURNEY

FOCAL POINT

NATIONAL GEOGRAPHIC
WASHINGTON, D.C.

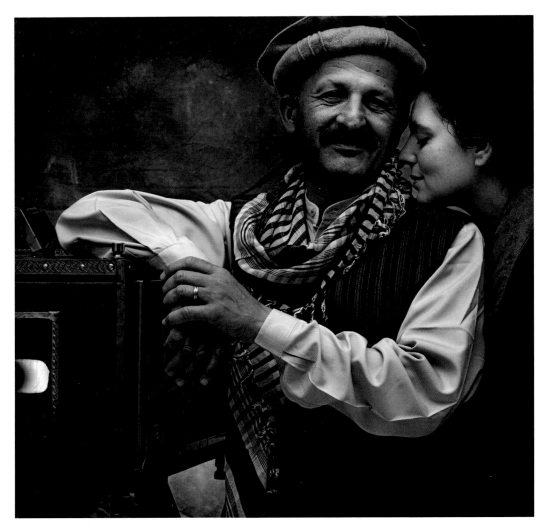

FRANCE | *2008*

*We dedicate this book to all those who have devoted their lives, over the course
of human history, to love, justice, and freedom.*

—Reza and Rachel Deghati

PREFACE

It is my belief that all the darkness of the world cannot put out the light of one small candle.

In my travels in war zones, natural disasters, and places of sorrow and beauty, I have often been reminded of the tale told by Rumi, the 13th-century Persian sage. It is a tale known to many cultures, the tale of villagers who had never seen an elephant and are frightened when one comes near their village. The three men who are sent to examine the beast in total darkness come back with three completely different explanations of what it is. This is because each has only touched one part — an ear, a leg, its trunk — and is misled into seeing that as an explanation for the whole. The different versions lead to deep divisions in the community based on which version each person believes.

IRAN | *1954*
family photo

As Rumi said, "What all three of them said was true, but not one grasped the Truth. If the light of even one small candle had been shed on the elephant, they would have been able to see."

As a child in Tabriz, my parents used to whisper to their children the poetry and tales of wisdom and love for freedom and justice.

For almost 40 years now, I have been using my camera as a tool to bear witness. As a teenager, I chose photography as my universal language. In the years since, in my exile from my native Iran, in the midst of wars, revolutions, and natural disasters, and also in moments of untold peace and beauty, I have always tried to shed the light of knowledge on the events of our time. It is my hope that, with this light, we may see the whole and not just the parts, the truth and not the illusion.

I have never stopped acting as a witness. I do this to contribute to building a world in which the word "war" will belong to the past. I believe that, one day, humanity will remember these conflicts as a form of behavior practiced by its primitive ancestors. Then, peace will have triumphed.

Though the world I have seen and photographed is a story filled with war and tragedy, injustice and heartbreak, I have come to see that it is also a tale of the power of hope and the incredible resilience of the human spirit.

— *Reza*

CONTENTS

AFGHANISTAN | *2000*

INTRODUCTION

BY SEBASTIAN JUNGER

The first time I experienced war— real war, the kind that eclipses every other concern in one's life—Reza and I were in northern Afghanistan in the fall of 2000. We were with Ahmad Shah Massoud, the beleaguered hero of the anti-Taliban forces, and a nighttime battle was going on a mile or so to the west. Some of Massoud's men had mistakenly attacked through a minefield, and Reza and I happened to be at a frontline medical station when the first of these wounded came in. They were laid out on cots in the harsh light of kerosene lamps, each man stunned and mute and confused. Everywhere I looked, there were sacks of muscle and tendon and bone where legs should have been. It made my head swim, and after a while I couldn't take it anymore and stepped outside to think things over.

The truth of the matter, I realized, was that I was a war reporter who couldn't bear to witness the results of war, and I was faced with the choice of going back inside the tent or bowing out of the profession for good. There was no middle ground. Eventually I managed to pull myself together and rejoined Reza inside. He was moving from cot to cot, furiously snapping pictures and muttering about the evils of war, and as I followed him with my notebook, I was surprised to find that what I was seeing no longer bothered me. It was as if everything had slid into some kind of abstraction where the men weren't really wounded, they were just actors in a weird, gruesome performance. I knew this wasn't true, but seeing it that way allowed me to continue working. I filled my notebook with horrors, and then Reza and I walked back to our truck and drove away.

There must be a psychological term for what I did that night; I just think of it as hitting the "abstract button." Almost every war reporter I know has figured out how to do that, but it comes at a price. Psychological defenses insulate us from reality, but that means they insulate us from everything—not only from people's suffering but also from their triumphs and their joys, their passions and their fears. In a very profound sense, we forget that these people are real and that their drama is every bit as serious and irreversible as our own.

I say all this because it was only through knowing Reza that I came to understand my own limitations as a journalist. Pointing a camera around a battlefield—or filling up a notebook—is a simple matter that doesn't say much about the deeper nature of things. Everyone acts the same when being shot at; it's one of the few true universals. Reza is able to push his work far beyond these easy truths, however, because he doesn't shut down; he lets it all in. These are his people. He wants nothing to separate him from them. The camera comes up. The images are captured. He mutters under his breath, and then he moves on. When I am confronted with wounded soldiers or starving refugees I can detect somewhere in my mind the reassuring thought that I could never be one of those people; they live in their world, I live in mine. It's a nice fantasy. Reza understands

what few journalists have the courage to face: We could all be them. Only a quirk of history has kept us from sharing the fate of the people we report on. It's the ultimate egalitarianism; it's the ultimate empathy.

Reza's photographs communicate this in powerful and subtle ways. I was standing by his side when he took the image of an Afghan woman holding the face of her dead son. Her grief is the grief of all parents, everywhere, who have lost a child or even worried that they might. There are military families in the United States who now have more in common with this grieving Afghan woman than they will ever have with some of their neighbors and friends. When Reza pushes the shutter, he understands that.

Reza's understanding of this common humanity compels him to act in ways that go far beyond his duties as a journalist. He and I were working together when Massoud's forces broke through the Taliban front lines and retook Kabul in the fall of 2001. (Massoud had been assassinated by al Qaeda two days before the attacks of 9/11.) One of the first things Reza wanted to do was to go to the city jail, where a Northern Alliance commander was holding several Taliban fighters. They were locked in a small basement cell with their elbows bound tightly behind their backs. To me they were just "Taliban," and I didn't feel much sympathy for them; in fact I think I can say I hated them. Not Reza; he understood that these young men may well have gotten swept up by political forces beyond their control, and that they weren't necessarily bad people.

"Look, they are locked up and can't go anywhere," Reza told the commander. "Why don't you at least untie them so they can be more comfortable?"

The commander couldn't come up with anything to say, so he had the prisoners untied. I have no idea what eventually happened to them—they could have been shot as soon as we walked out the door—but in a sense that wasn't the point. Reza understood that he was in a position to help these men, and so he did. To him they weren't prisoners, they were just people in prison. What a difference it makes to put it that way; what a difference it makes in how you think, how you act, how you understand the world.

Reza is a great photographer because he sees the common humanity in people, and he sees that humanity in people because he has studied them so hard through his camera lens. The truth flows in both directions through Reza and enlarges him at each pass. A corollary to the idea that we journalists could easily be Afghan refugees is the (vastly more heartening) idea that they could be us, as well. By that I mean that there is nothing inherently corrupt and violent about the developing world, nothing inherently desperate about its populations; history just turned out that way. The poverty and injustice that blossom there like some kind of deadly flower could just as easily take root in the West; it may well yet. And within a few generations, the power and wealth of the West could be attained by much of the developing world; there are no laws of nature declaring that it cannot.

So when Reza looks at a young Afghan—or a Rwandan or an Egyptian or a Palestinian—he doesn't just see the product of a ruined world; he sees the potential citizen of a better one, as well. After Kabul fell to the Northern Alliance, Reza set to work establishing a center to train young Afghans to be journalists. His reasoning went like this: It is impossible to achieve economic freedom without political freedom, and it is impossible to achieve political freedom without

freedom of the press. To have freedom of the press, however, a whole generation of Afghans will have to be introduced to the concept and trained in it. So while American and other coalition forces were spreading throughout Afghanistan delivering aid and security, Reza rented a building in Kabul and started training the next generation of journalists in Afghanistan.

What he was doing reminded me of something I wrote about Massoud in 2000. For five years, Massoud waged a brilliant guerrilla war against Taliban forces who were backed by Pakistan and outnumbered him three to one. He did this by thinking on a strategic level that his enemies couldn't even comprehend. "The Taliban shipped the bulk of their forces to the Taloqan front," I wrote about one particular battle in the north. "Massoud arrayed his forces in a huge V around the town and began a series of focused, stabbing attacks. In the meantime, he was thinking on a completely different scale. Massoud had been fighting for 21 years, longer than most of the Taliban conscripts had been alive. In that context Taloqan didn't matter, the next six months didn't matter. All that mattered was that the Afghan resistance survive long enough for the Taliban to implode on their own."

That was what I saw in Reza as we drove around the rubble of Kabul in November 2001: A man who was thinking years into the future and in the broadest possible terms. Maybe coalition forces would go home after a few years and the Taliban would take over again; maybe the new government in Kabul would be as corrupt and horrible as all the others. Reza had no way of knowing. But what he did know was that without a working press corps, Afghanistan could never achieve lasting freedom and dignity. It's demonstrably true that a thousand trained journalists will strengthen a democratic government and weaken a tyrannical one. So what do you do? You train a thousand Afghan journalists and tell them—as Massoud told his original guerrilla fighters—to spread out and train a thousand more, and to just keep doing that until the war is won.

Reza knows that tyranny has no chance against such numbers; Reza knows how fragile tyranny can be. Through the lens of his camera, Reza has shown us how the world really is. What I am just now understanding is that through that same lens, Reza has also seen what the world might one day be.

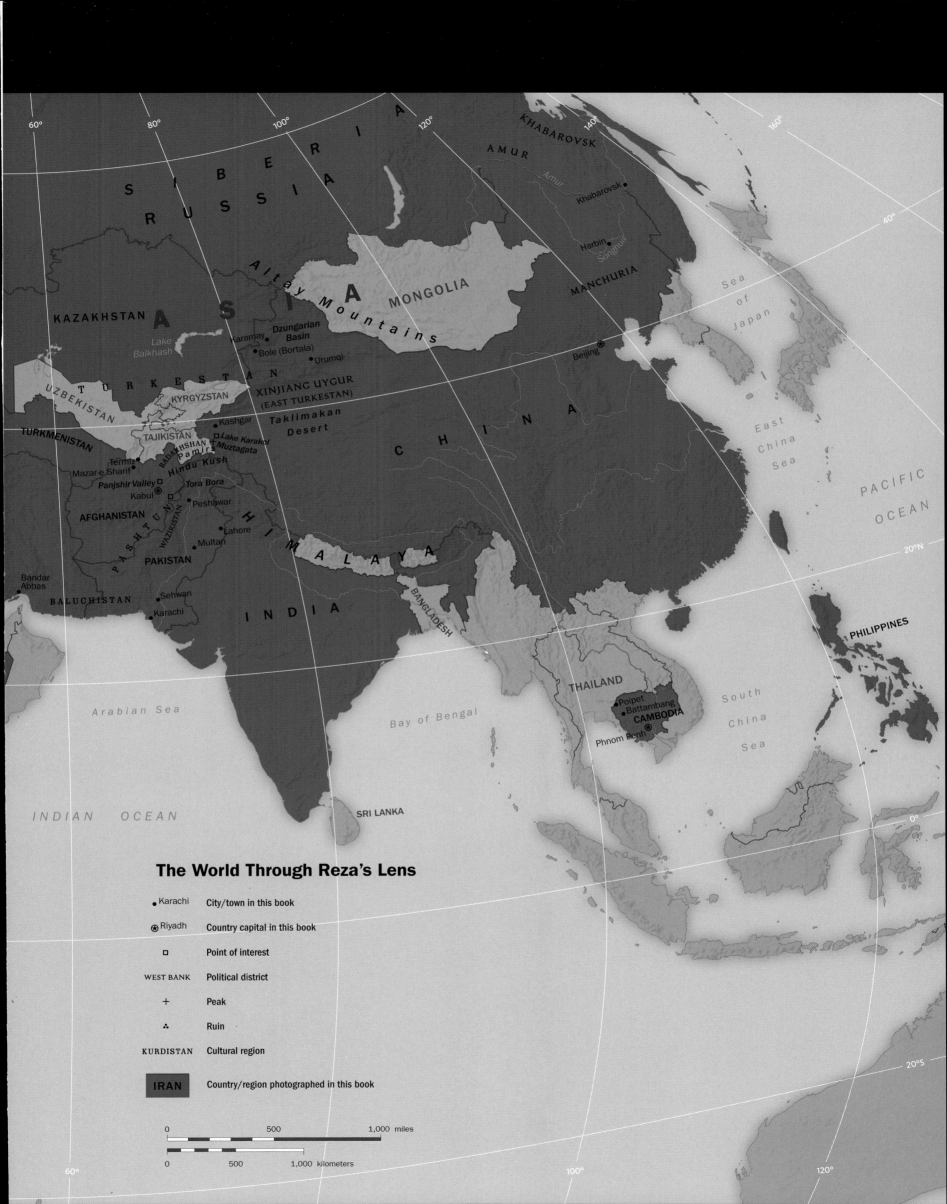

The World Through Reza's Lens

- Karachi City/town in this book
- ⊕ Riyadh Country capital in this book
- □ Point of interest
- WEST BANK Political district
- + Peak
- ∴ Ruin
- KURDISTAN Cultural region
- IRAN Country/region photographed in this book

0 500 1,000 miles

0 500 1,000 kilometers

Nothing. At last, I had the opportunity to photograph Ayatollah Khomeini in an intimate, private setting. This would be my chance to try to gain some understanding of this man who had become such a powerful enigma. I was led in to see him. He was sitting in this bare room, which had no past or future, no history or memory. I had time to take only three photos. Then, he cut me off, saying harshly, "I'm tired." Throughout our session, he never looked me in the eye. I had sought his gaze to silence a doubt that had lurked in me since his return to Iran a year earlier. When he arrived, a reporter had asked him what he felt about being back after 15 years of exile. His reply: "Nothing."

He was the symbol of hope for an entire nation. We had risen up against the shah in a revolution that had erupted spontaneously throughout the country. But after my brief encounter with Khomeini, the doubt I felt gave way to the certainty that a fist was about to come down on our dreams of justice and freedom.

A year after I took this photo, I left Iran, forced into exile. Earlier, I had been arrested by the shah's secret police for being a dissident. I was imprisoned for three years and tortured for five months. Now, because of my photographs showing the repression carried out by Khomeini's regime, I was under threat from his government, and had to flee. In the years since then, I have been a nomad searching for a part of my homeland in every country I visit—a quest that is like picking up and reassembling the scattered pieces of a puzzle. My camera is always looking for the truth that often hides in the shadows of events.

IRAN | *1979, first massive demonstration against the shah*

In the sixties, Western women had burned their bras in the name of liberation. For them, freedom meant shedding the restriction of feminine dress. In Iran, the advent of the Islamic Republic forced Iranian women to cover themselves. They had to wear the veil and long cloak of the traditional chador. Their bodies hidden by this uniform, they lost the right to be seen as discrete beings but won the "prestigious" title of "sister." Under the new ideology, they were also led to believe that they would be considered equal to men.

A group of women called the Sisters of Zahra undertook to hunt people down in the streets, looking for any infraction: the too-short cloak, the nail polish on the fingers, the lock of hair showing out of the veil, the furtive meeting of two lovers' hands. Without mercy, they made anyone, male or female, pay dearly for daring to contravene the new order of the Islamic Republic.

Many of the women who wore the chador took part in demonstrations, and were spiteful and violent. They marched, brandishing a fist or a rifle, chanting slogans of submission to the Guide—the Supreme Religious Guide, Ayatollah Khomeini. Sheep in black, they seemed to have lost all individuality.

For months, I had watched the black chadors take over, becoming more and more widespread in the towns and the countryside. Yet Iran has a variety of people, a multiplicity of colors and landscapes. Even though decades have passed since I last saw them, I can still recall the rural women with their colorful petticoats, which contrasted with the red of their houses, made of clay. And I can still see the vividly colored rugs and the fabrics with the elaborately worked embroidery.

When I entered this fabric shop, where the only choice lay in the weave of the material, I felt stifled and depressed. The only style available was for the chador; the only color offered was black.

During those days, I often felt that, unconsciously, the people of Iran had agreed to go into mourning.

IRAN | *1980*

IRAN | *1980*

On a rainy November morning in 1979, some militant Islamic students invaded the American Embassy in Tehran, taking the diplomats hostage. So started an intense showdown between the United States and the ruling mullahs that was to last 444 days. I covered this event for its entire duration, providing photographs for *Newsweek*. The students, thrust into the media spotlight, organized a press conference the day after the takeover. They displayed pictures of the blind-folded hostages. I took their picture. I wanted to show, though no doubt I did it very subconsciously, the perverse and contradictory essence of the mullahs' regime. The Islamic Republic had established its power through the frequent and expert use of images. The very first photographs of the demonstrators killed

under the regime of the shah helped propel the Iranian revolution. For the mullahs, an image was a genuine weapon.

The occupation of the American embassy turned the embassy into the nerve center of the revolution. The stage for a provocative and vindictive theater, the embassy was the site for some new spectacle each day. Every event became the pretext for a crowd to gather at this "center of the world." Whether the event was a demonstration, a fresco painted with the recurring call for the "liberation of the oppressed Muslim peoples of the world from the satanic American hegemony," a firebrand speech, a press conference, or the freeing and transfer of the hostages, people came by for a daily stroll.

IRAN | *1980, first anniversary of the revolution*

IRAN, KURDISTAN | *1979*

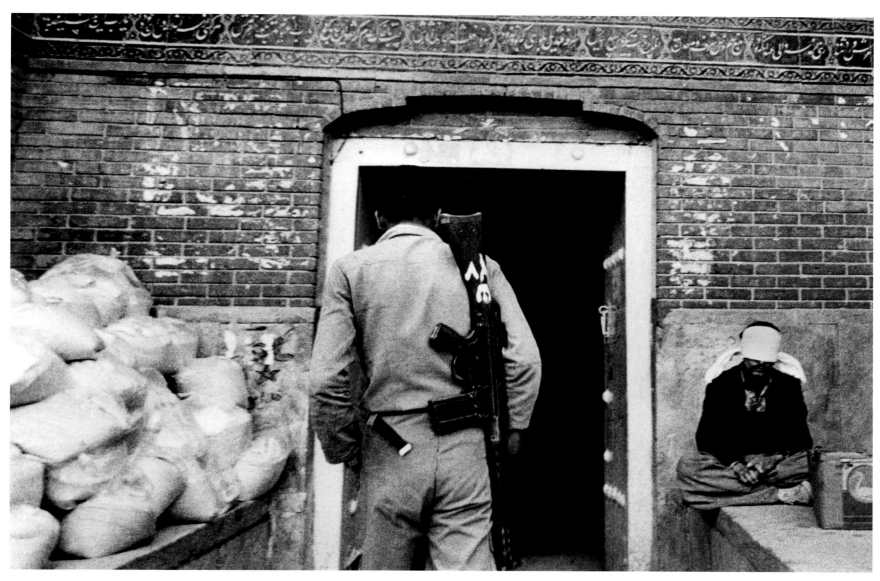

IRAN, KURDISTAN | *1980*

Imagine for a moment that you are on assignment somewhere and you hear the deafening sound of a fleet of fighter planes; they are coming in to attack that place in order to destroy everybody there. This threat looms day and night, without respite. Your stomach is tense with fear, but you walk on, preferably at night so that no one can see you. You try to reassure yourself—you are neither an attacker nor a member of the armed resistance. Your weapon, your reason for being in this place, is your desire to provide witness to what others cannot see. You are a messenger. Hanging on to this idea, drawing bravery from it, you continue to walk on.

I was in Iranian Kurdistan. The Kurds actively took part in the resistance against the shah's dictatorship in 1979, and also participated in the Iranian revolution, pursuing their dream of achieving an autonomous Kurdistan after the victory. But after Ayatollah Khomeini seized power, the Kurds were called "sons of Satan." The government ordered the relentless bombing of Kurdish cities and rural communities. A resistance movement started to grow; even women, farmers, and intellectuals had to take up arms and go underground. In the city of Sanandaj, the Iranian Revolutionary Guard Corps responded to the unrest of the people in the besieged city by carrying out bloody reprisals and mass arrests. The prisons became so overpopulated that the mosques had to be converted into jails. One day I was arrested while covering a story, but before I was brought in for questioning, I was able to hide the few rolls of film I had taken. At the entrance to the mosque, I had the time to capture this image, which I took on the sly, of this blindfolded man who was awaiting his upcoming execution.

Splintered among four countries—Iran, Turkey, Iraq, and Syria—the Kurdish people are fighting for the recognition of their language, their culture, and their social and political identity. Many of the Kurds who make such demands are arrested, tortured, or forced into silence or exile.

IRAN, KURDISTAN | *1980, Kurdish house bombarded by Iranian Revolutionary Guards*

"My mother was looking for me," a boy named Peyman told me. "Sitting under a dead tree in a desert of grass burned up by chemical bombs, I didn't answer.

"'*Peyman, Peyman!*' The words were distant and faint.

"'*Peyman, Peyman!*' Her sweet voice was becoming more anxious.

"What was she afraid of? Did she think she had lost me?

"Our land is arrayed with a winter coat.

"Our land is made up of mountains, mountains that hide the armed resistance.

"Our country has been stolen, its plains and immense fields planted with mines by invader after invader—the Iraqis, the Turks, the Iranians, and the Syrians.

"Our land, this homeland that they refuse to give us, is the shroud of a people in mourning.

"'*Peyman, Peyman!*' My mother was getting closer, but despair had already swept through me. I didn't have the heart to show her my face full of tears. And I didn't have the heart to call up for her the grief of my father's death, or the memory of the earth that had recently been turned over on him. I had sat by his grave for a long time.

"She thinks I am too solemn. But how can I not be? She often says she wants to kill the person who took my father and stole my carefree, childhood laughter. She tells me I am too quiet and alone. I do take refuge in silence, that is true, and whatever peace I find is solitary. I think about the future. Will I be forced to take up arms and fight out of hatred, in order to free my people? I would like to play and be with children my own age and fool around with pretend games and toy pistols, but I can't. My friends have become hardened. The streets are overrun with the enemy, but my friends are roaming the streets, acting rebellious and unconcerned.

"'*Peyman, Peyman.*' Filled with emotion, I listen to the murmur of her tired voice, worn down by tragedy.

"Smiling to hide my despair, I show myself. She sees me. Her eyes are almost happy. Despite the weight of her suffering, her features still look soft. I am 11. I live with my sister, Leila, my mother, and my grandfather, and we are going to have to go on, without my father. She walks toward me. She waves for me to come over."

IRAN, KURDISTAN | *1980*

Peyman went on, telling me:

"What else is there to say about my life, about our fate as a people who are refused an identity? What about you? You say you know a little about us through your camera lens. You say you will tell the world about us. But I have a hard time understanding how you will do this. Come, I will introduce you to my grandfather."

We went to his house, where we had tea. I thought about the Kurdish children I had come across, their eyes full of sadness. Peyman was watching me attentively, but seemed distracted. He appeared weighed down, as though he were dozens of years older. Despite their grief, his family welcomed me. After we finished the tea, I left the sad warmth of their home. As I reached the corner of the street, I heard a violent blast. Then there was silence, then screams, the despair and horror of a mother whose children have just been torn from her. I turned around. In the dust of the dirt and rocks pulverized by the bomb's impact, I saw some motionless bodies.

Peyman, his sister, and his grandfather had just been murdered—bombed by the Revolutionary Guards.

The story of Peyman is the fate of the children of Kurdistan.

IRAN | *1981*

My life was turned upside down one fall day in 1978. I was working for an architect in Tehran at the time, and was in the architect's office. Suddenly, I heard a strange, unfamiliar shout. Some angry protesters were screaming: *"Marg bar shah!"* ("Death to the shah!"). I went to watch them from the window. Soldiers came and blocked the street from both sides.

The soldiers shot blindly into the crowd. The students could do nothing. Some died instantly, falling to the ground. Others, wounded, crawled away to protect themselves. Still others ran for shelter. Then I saw one student who was fleeing but taking pictures as he ran.

I stayed by the window for three hours, transfixed by the chaos below and in a complete state of shock.

I made a decision. That night, I gave up my job. I turned in my keys to the architect's office, and I took up my cameras, which I haven't put down since. Instability ruled in Iran; unrest and demonstrations were occurring everywhere. At event after event, I met Don McCullin, Marc Riboud, Olivier Rebbot, and Michel Setboun, among many other photojournalists who had come to Iran from all over the world. They showed me the ropes. After a few months, my photographs started appearing in the international press.

I became a correspondent for Sipa Press and for *Newsweek*. I covered the revolution, the riots, the war against Iraq, the war against the Kurds—Iran was boiling. The utopian fervor of the revolution had soon given way to repression. The shah had been brought down, but the mullahs who took power crushed every form of opposition, every difference of opinion. The first victims were the former political prisoners who had fought against the shah. This carnage led me to a sad observation: Hasn't history shown us that every revolution eats its own young?

In February 1981, I was wounded on the Iran-Iraq front by a shell blast. The Iranian government was closing down the borders. My wound served as a pretext for me to leave the country. I went overseas for medical treatment. A few days before I left, I had learned that I was a wanted man, sentenced to death because of my photographs. My journey outside my country would be a long one.

Iran had become a huge cemetery, where figures dressed in black wandered among the tombs.

FRANCE | *1985*

The long road of exile. One spring day in the small house in Paris where I live my life as an exile, my six-year-old son, Delazad, whose name means "free soul," drew me out of my daydream. "Papa," he said, "tell me about Iran." Iran? How could I tell him about the country's roots? My roots? His roots? I was quiet for a long while, thinking. No doubt he understood that I was on an inner voyage, traveling back into my past, because he said nothing and waited, like a child who is expecting a wonderful bedtime story. + I started by telling him about the Iran of my childhood. "For as long as I can remember," I said, "my father used to come home from work in the afternoon and then would settle down for the rest of the day in his study, a sanctuary that belonged to him alone. It was decorated with Persian rugs and comfortable pillows, and it had many books. + "A teapot was set on a samovar. And on a tray, tea glasses and cookies awaited his guests. My brother, my sisters, and I were not allowed to go into that room. For us, it was a mysterious place, and we couldn't make any noise as we passed by it so that we wouldn't disturb him as he rested, read, or talked with his friends. When I was six, he announced to me that I could come into the room and stay there with him. I was a big boy now, he said. I was proud of that recognition. Then, when I stepped into the room, I discovered a world I had never suspected. For the most part, the guests who came to visit my father were intellectuals, thinkers, and poets. While drinking tea, they would talk or read poetry for hours on end. Over the course of these afternoons, I came to hear the love poetry of Hafez; *The Rose Garden* by Sa'adi, the wise traveler who worshipped love and peace, as expressed in every flower petal, smile, or scent; Ferdoussi's allegorical tales; and the life lessons of Rumi, the

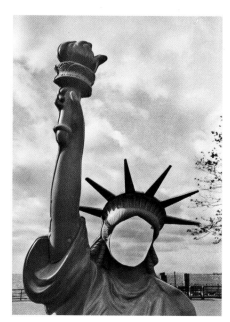

NEW YORK | *1988*

dervish. The time I spent in my father's den helped form my thinking and gave me a grasp of Iran's complex past and its refined and rich culture. Compared with today, the Iran of the past had much more freedom of thought. In the company of my father and his friends, I learned to value freedom. I understood that every one of us has a little flame that allows us to resist any kind of invasion. The years I spent listening to those men talk gave me a taste for three words: 'love,' 'freedom,' and 'justice.' I have devoted my life to living by those three words." + Delazad was listening to me with the same kind of sustained attention as I used to have when I tried to follow what my father and his friends were saying. Speaking with the aptness typical of children, he looked around us and said, "After all, our home is a little bit like Iran." Then he went away to play, which left me to go deeper into my thoughts. He was right. After years of wandering, I had finally set up a home, a hearth where cultures are bridged and intertwined. Delazad and his sister, Djanan, belong to two nations, and are from both Iran—where they still cannot go—and France. Rachel, my wife, who is French, and I have raised them to respect the fundamental idea of universal citizenship and live by that spirit. + On March 25, 1981, at 7:35 in the morning, I left my country with my camera bag. It was a fitting way for me to leave since it was in the name of my work as a photographer-witness that I had been sentenced to death. On that day, I set off on the long road of exile. + Since then, my inner journey has been the wandering of a nomad roaming around a forbidden land. Without a doubt, my first years of exile were strongly marked by the shock I felt when I realized the gap between my idealized image of a free West and the reality. Western democracies turned out to be as arrogant as they were disappointing. My experience of freedom had an empty face, and my exile was filled with doubt and sadness. One rainy, somber November day, I went with a group of fellow Iranians to the Père-Lachaise Cemetery in Paris. We were accompanying the thinker and writer Gholam-Hossein Sa'edi to his final home. By his graveside, we tasted the bitterness of death and interment while in exile and imagined the sorrow, for him, of knowing that his flesh would be mingled with an earth that was not his. I took a photograph of our sad procession through the cemetery. Some time later, as he was looking at the image, the poet Ahmad Shamlu said, "Even a statue of stone cries and moans on the day of separation from the beloved."

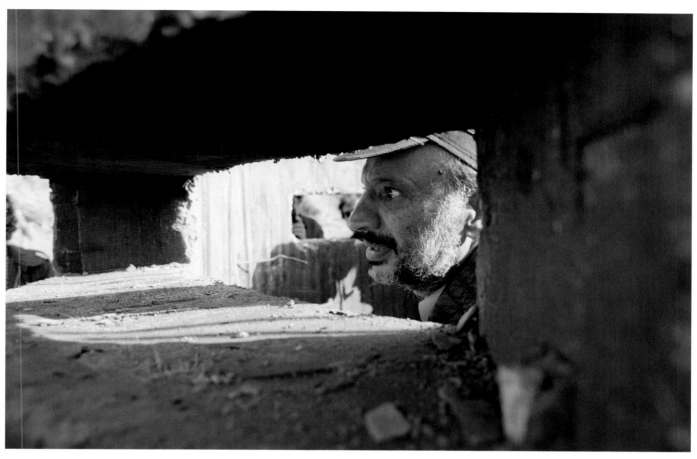

LEBANON | *1983*

In 1982, the children who lived in the Palestinian refugee camps of Lebanon played like children everywhere: They kicked balls or pretended to be soldiers, using pieces of wood as toy pistols.

Over the years, though, the innocence and spontaneity of their games disappeared. As Israeli attacks increased, the sudden raids, the images of horror, and the massacres began to dominate their imaginations. Wearing hoods, they roamed as gangs in the ruins of bombed-out, deserted houses, and their weapons were realistic wooden rifles.

Images tell stories, and sometimes they reveal truths. They can also create an opportunity for us to stand out and distinguish ourselves. After the Israelis defeated the Palestinian fighters in 1982, their leader, Yasser Arafat, had to retreat to Tunis. Rumor has it that he returned to Lebanon disguised as a fisherman. In 1983, the Syrian Army laid siege

to northern Lebanon. Arafat went to the front with an entourage of journalists, myself included. Our group was far from discreet. His audacity provoked the wrath of the enemy, who dropped shells on us. Arafat's bodyguards pushed him into a bunker just in time, and we scrambled for shelter behind him. As I reached the bunker, an image crossed my mind: that of Henri Cartier-Bresson, who, during Gandhi's funeral march, turned away from the casket in order to capture the emotions of some of the faces in the crowd; he was the only photographer to do so. I took a picture of Arafat. I was the only journalist to get an image of his face while he was under attack. Selected by *Time* magazine as one of the photographs of the year, it became an iconic image of the Palestinian conflict.

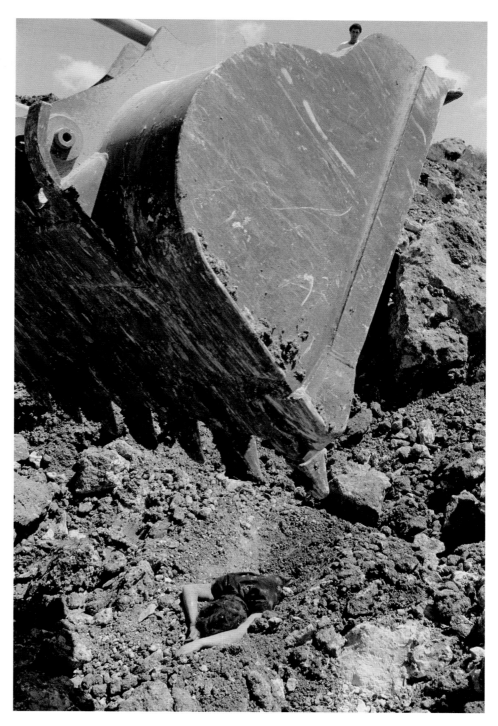

LEBANON | *1982*

My first book had a black cover with an image of a city on fire and had the following title, which stood out against the dark background: *Peace for Galilee: Beirut.* In 1982, I spent all the money that I had earned covering the conflict in Lebanon for *Newsweek* and Sipa Press to publish the book. Over the years, it has become my memorial of the war, and it will always remain a tribute to those who suffered because of Operation Peace for Galilee—such a "sweet" name for such a violent reality.

Since the start of the conflict, the daily life of Lebanon's religiously divided population had been nothing but civil war, violence, hasty burials, terror, shortages, and flight. The military operation had begun on June 6, 1982, with the invasion of southern Lebanon. Bombs then laid waste to Beirut in a morning raid. Taken by surprise, the terrified population didn't know whether to hide or flee. Everywhere, silence and panic: Store shutters closed, streets became deserted, the people who remained in the ghost town hid like hunted animals. The ones who fled risked being bombed, as well. On the road to the city of Khalde, a bus carrying children and their teacher had to stop to avoid being hit by one of the Israeli bombs. The young female teacher had the time to lead all of her students to shelter under a bridge before a bomb hit her—a victim of the blind injustice of war.

Many of the countries in Africa gained their independence after World War II. Often, they have artificial borders, arbitrarily drawn up by their former colonizers, who had to cede power to the leaders of the countries' independence movements. But after years of rule, some of those "liberators" have become dictators, often supported by the ex-colonists. Such was the case with Ahmed Sékou Touré, who ruled over Guinea for 25 years. His death, while he was abroad, left a power vacuum that led to a battle for control. I was among a group of about a hundred journalists authorized to cover his funeral. After the funeral was over, we were supposed to leave the country, going without being able to cover the struggle for succession, which would occur in the darkness of misinformation.

Pleading that I was physically ill, I asked to stay for a few more days. Three days later, a military coup d'état took place. Though peaceful, it put a stop to the rivalry for Sékou Touré's throne, and marked the end of his regime. Ecstatic, the newly freed population celebrated. In the streets, people sang Bob Marley lyrics and danced to the beat of drums. Every image of the man who had ruled in terror was obliterated.

Stone in hand, this boy spent all day long scratching out every portrait of Sékou Touré that he found on his way. This photograph went around the world. Some months later, I heard from a fellow journalist that the image had turned into a kind of symbol. It had been widely distributed in other countries in Africa, where it was used to deliver a message of hope: "Look, you can erase dictators."

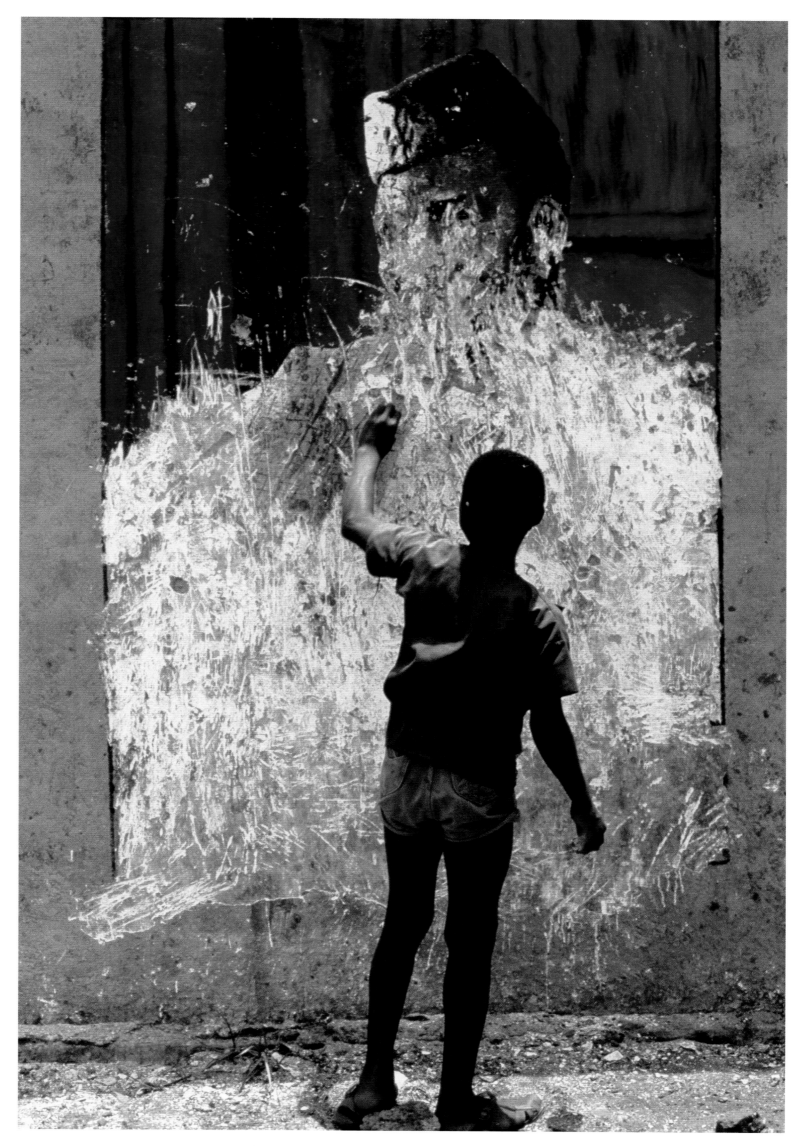

Breakers of empires. Perhaps you have grown up with images of a magical and mysterious world, such as that described in *The Thousand and One Nights.* Inviting a voyage of the imagination, these stories conjure up that fabled world.

During my trip to Afghanistan in 1983, the countryside and its people seemed to have remained immune to the changes brought about by time, industrialization, and foreign influences. Everywhere I went, the proud and immutable integrity of the Afghan people was palpable. I remember the despair of an old man whose house had been razed to the ground during a Russian bombing raid. As he showed me the ruins, he told me, in a voice broken by sobs, "The bird of fire came and destroyed my house."

The Afghan resistance was small and poorly equipped. Nevertheless, it was far more determined than the Russian occupying army. After sharing the life of some of the Afghan resistance fighters, I knew that the resisters would force the Russian Army to yield and retreat, just as their ancestors had done with other occupiers.

I had come to Afghanistan after being hit by an Israeli phosphorus bomb while covering the war in Lebanon. I had spent two months in the intensive care unit of a Paris hospital, but still was not well. The doctor advised me to get some rest in the pure mountain air of the Alps. Instead, I chose to go to the mountains of Afghanistan.

This was how an ineffable bond began to grow between the country of Afghanistan and me. Even 25 years later, this bond is still strong. Like Ariadne's thread, it continues to help me find my way in the labyrinth of my life as a nomad.

The Soviets, emboldened by their military strength, thought they could rule over Afghanistan as they had already done with many of the southern "provinces" in the U.S.S.R. I took these two photographs crouching on the ground near Kabul. The fight was uneven, as the Russian missiles outmatched the resistance fighters' machine guns. Nevertheless, Afghanistan never fell into the hands of the iron invader.

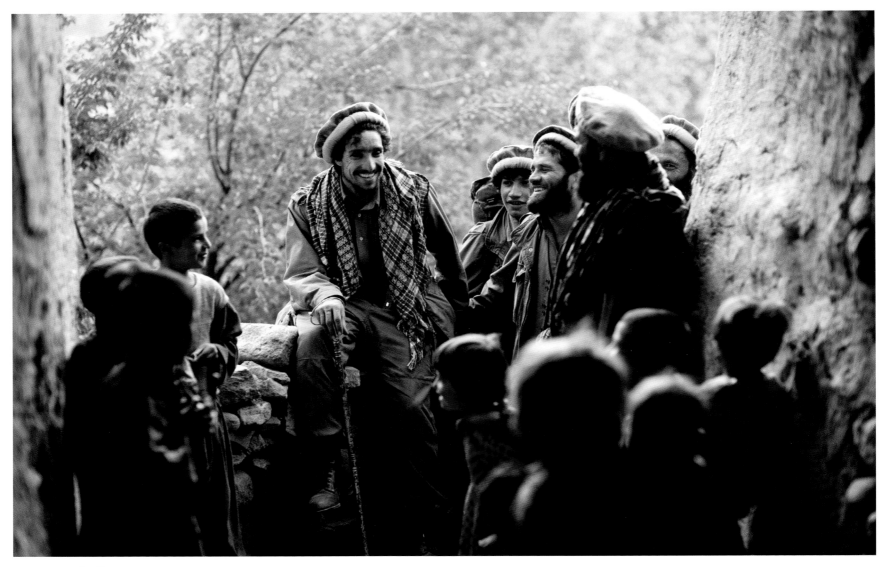

AFGHANISTAN | *1985*

Eluding Russian soldiers, we had spent several weeks hiking in snowstorms on long, painfully difficult trails in the Nuristan Mountains. My traveling companions and I wanted to reach the Panjshir Valley and the man I wanted to meet—the man, in fact, a hundred thousand men of the Red Army longed to kill—the leader of the Afghan resistance, Ahmad Shah Massoud.

It was May 23, 1985. We were in the square of a village where we had spent the night. It was still very early morning. A group of men climbed swiftly down the mountain toward us. Then I saw him. He had the bearing of a prophet and the warmth of a simple man. "I know what you have been through to get here. I am sorry for making you wait," he said as he hugged me. That day marked the beginning of a trusting friendship of 16 years. As the years went by, I was able to observe him on many occasions. A man of rare intelligence and profound sensibility, he had an extremely acute sense of justice. His sense of honor had led him to join the

resistance in order to defend his country. Massoud loved his people, and his people loved him. He was a great listener, remembering every detail, every name, every request.

Minutely involved in every aspect of the resistance fighters' daily life, he nevertheless refused to be all-powerful. One day a man came to ask him to intercede on behalf of his son, who had been sentenced for treason. Massoud replied, "The release of a prisoner can only be done through the justice system. By what right can a leader decide the fate of a guilty person? When there is a judge, the leader has no power."

Weary of the wars he had waged, Massoud told me: "When all this is over, I'll finally make my deepest wish come true. I will become a schoolteacher in the Panjshir Valley."

AFGHANISTAN | 1985

AFGHANISTAN | *1985, refugees fleeing Russian aerial bombardment*

AFGHANISTAN | *1986*

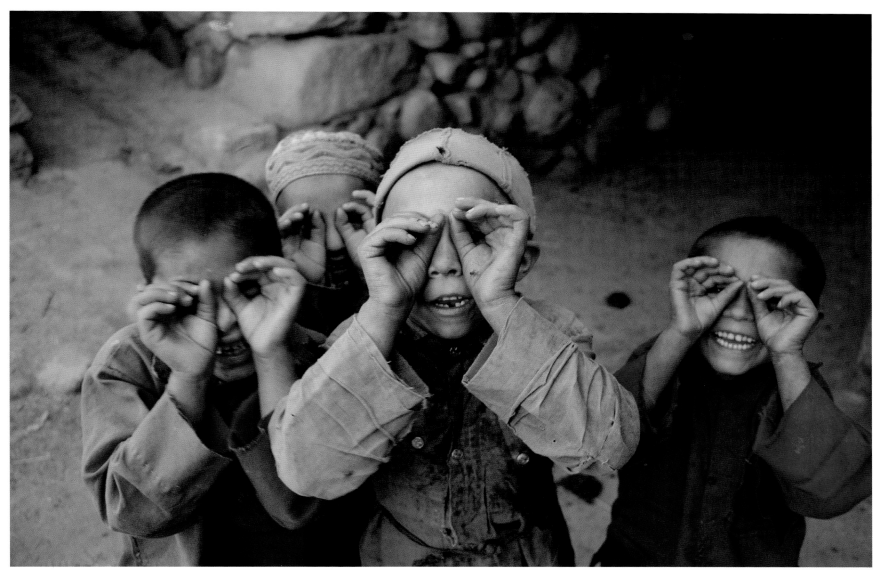

AFGHANISTAN | *1985*

Preceding pages and opposite: The war against the Russian invaders had been raging for four years. Afghanistan was a scene of terror, from the towns to the countryside. The Russian soldiers were gaining ground. The Afghans rushed to get away but faced natural obstacles, such as the Konar River, in southern Afghanistan. I was by the river as one group of Afghans tried to cross it. Upon reaching the river, they commandeered some makeshift barges and scrambled aboard. Amid the pushing and shoving, several people drowned or were trampled to death. Others managed to survive by grabbing on to the barges. Russian soldiers flew in helicopters overhead and fired at the Afghans, who were far too easy

targets—the barges were in the middle of the river. Of that day, all I remember is the chaos. Walking a short distance away, I came to an arid plain, where I saw this old man and his granddaughter. Proud, but destitute and vulnerable, they remained silent, huddled on the rock-strewn path of exodus.

Above: Pakistan was far behind me. My feet were tired from weeks of walking and hiking up mountain slopes. I was exhausted, physically worn out by the harshness of the weather, the lack of food and rest, and the constant tension of worrying that the Russians might ambush us. Nevertheless, I kept moving forward, motivated by my desire to reach the Panjshir Valley and meet Massoud, the young commander of the Afghan resistance. As I continued walking, I suddenly found myself in front of one of nature's gifts, the place where the mountains of the Himalaya meet those of the Hindu Kush.

I arrived in a village. The children rushed up to me and surrounded me, as children often do with strangers here, and they began to imitate me, playing at being photographers. Their laughter, their warmth, and their spontaneous friendliness erased all of the fatigue and discouragement I'd felt. It reminded me of a beautiful truth I had read in James Rumford's book *Traveling Man: The Journey of Ibn Battuta, 1325-1354:* "Traveling—it offers you a hundred roads to adventure, and gives your heart wings!"

Fleeing the war, the old man had left his mountain village and his past behind. He had settled with his family not far from the border. They had stopped there, within sight of the Afghan mountains, when he had raised his hand and waved the caravan to a halt. He had said he would not go any farther. He told them that they would set up camp there, and that his decision was final. Although his decision was against all reason, since they were still within reach of the Russians, it was irrevocable. Nobody dared contradict him. He was the family elder, the wise man, so his relatives followed his wishes.

He spent his days reading the Koran or poetry.

My own exile was still recent. He said to me, "Your house, your country, your history are within you, if you let them enter. Wherever you are, they follow you." But then, with a sigh, he admitted, with his eyes fixed on the slopes of the Afghan mountains, that he would not be able to survive without seeing his land, each and every day that God granted him to live.

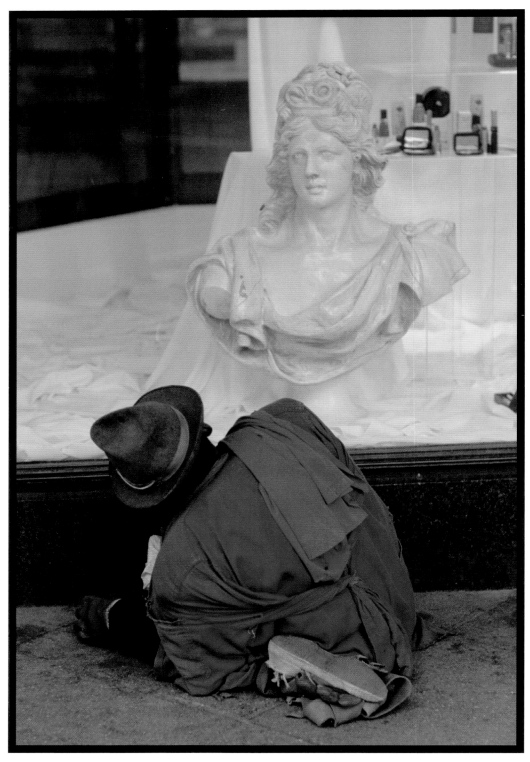

SOUTH AFRICA | *1985*

Apartheid. The word still resonates like an insult to my ear. Until very recently, apartheid was a basic social value in South Africa, the foundation of a white society that was convinced of its superiority, not only over anyone who was not white—100 percent white—but also over the rest of the world, which had, by law, abolished racial discrimination. In those days, Nelson Mandela, the leading figure of the resistance against apartheid, was still behind bars. It was August 1985. The idea of organizing a peace march to Mandela's prison in Cape Town had been launched by Desmond Tutu. The country's white government obviously would not allow me to cover this event. So I went to the South African Consulate in Paris and obtained permission to enter the country by presenting myself as an elephant hunter! The story would be funny, if not for the horror I discovered when I arrived. ✛ Bloody confrontations took place every day between blacks, nonwhites, and police officers. No day would go by without riots breaking out in the shantytowns. Everything in the streets smelled of tear gas. South African society was structured as a compartmentalized hierarchy. The English and the Dutch had competed for power in the country, occupying this prosperous land for centuries. In 1948, after the Afrikaners gained ascendancy over the English, they established colonialism, racism, and white superiority as principles consecrated by law in South Africa. The rest of the world was moving toward the abolition of any form of racial discrimination; former colonies were regaining their sovereignty; and nonaligned countries were starting to get organized as an opposition force on the global scene. Although these changes were occurring elsewhere, the whites in South Africa continued to cling to a social system in which subjugation still existed. Black and colored communities were separated and their people were scattered throughout the country in order to prevent any kind of contact and interaction between them. I covered the events troubling the country, traveling in South Africa for several long months. Though the people who supported the abolition of apartheid were always helpful to me, the police were fearsome, violent, and hateful. In October 1985, the black workers who toiled like slaves in the gold mines staged uprisings. Their rebellion marked a major turning point on the long road to the abolition of apartheid, which occurred in 1990. ✛ Still, after 30 years spent covering story after story, I have yet to find an ideal society, and can't help but see how much remains to be done to make the world a fairer place. Although legally enforced apartheid no longer exists, there are still great gaps in wealth between people. In the United States, South Africa (and Africa as a whole), India, and Europe, words such as "apartheid," "colonialism," and "slavery" are but a memory of the nightmares of history. Social apartheid, however, persists, a scourge that still needs to be fought.

The shantytown of Crossroads, in Cape Town, was an oppressive scene of human misery, where people shuttled between destitution and the struggle to survive, between rebellion against the Afrikaners and desperation in the face of a bleak life with no way out. Since the 1970s, tension had been building in South Africa's shantytowns, precarious settlements built of makeshift huts. Although their country's soil was rich in gold, the black people who worked the mines could only peek at it as they extracted it from the ground. The wealth from the gold went to the mines' owners, part of a white minority that clung to racial segregation despite international pressure. Enduring daily oppression, the black community protested more and more each day. Nonetheless, the level of their poverty was overwhelming. This couple, from an era that is now gone, made me think of Walker Evans's devastating photographs of poverty in America during the 1930s.

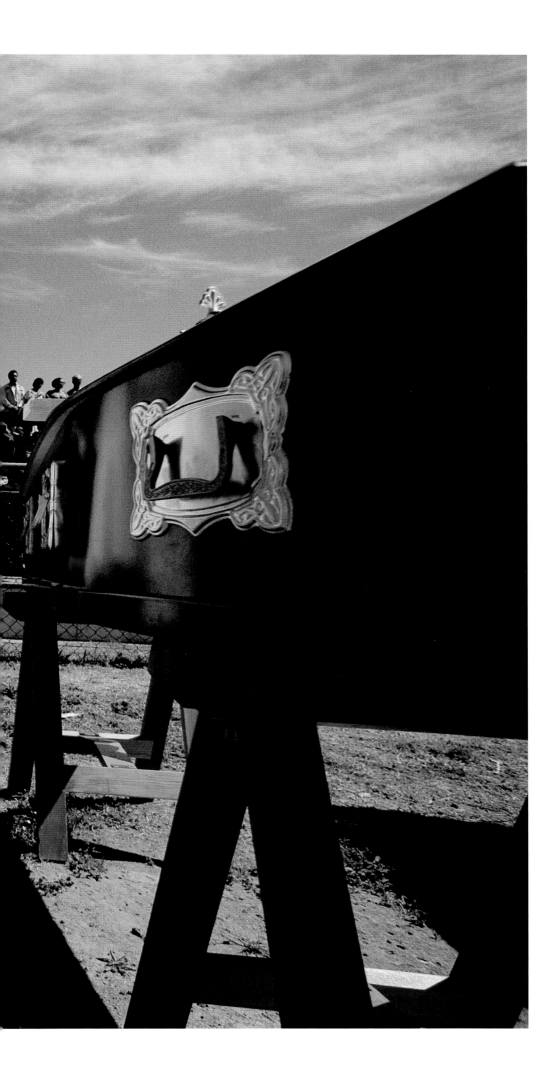

To break the stranglehold of white supremacy, young blacks in South Africa had no recourse but violence. Few white police officers dared to venture into the poverty-stricken districts where the black people were forced to live. Sometimes just the fact of being black was enough to make a person guilty in the eyes of the police. Violence was everywhere, and black youths were beaten, often to death, by the vicious blows of the white officers. On this particular day, a couple of dozen caskets had been lined up in rows in the shantytown of Crossroads. In keeping with local tradition, a girl stood by the caskets wearing a bridal veil. She had it on for only a moment, enough time to signify that she was symbolically accompanying the young people in the caskets, who had died before being able to dance on their wedding night.

Over the years, while covering revolutionary conflicts in various parts of the world, I have used my camera to bear witness to the violence men wage against one another. Through the images I have captured, I have also told the stories of the women who were caught up in these conflicts, the first victims of wars they had not chosen to be part of.

They have lived through the deafening noise of raging cannons; endured the pain of sons, brothers, and husbands killed in action; watched people flee, and known the silent tears of those who stayed behind. Fighting to survive, these women live in a constant state of suffering. But far from causing them to break down, the violence and pain they face lend them dignity, tenacity, and patience. Contending with the evils of war—the scourge of mankind—they convey strength and a moving inner beauty.

With my camera, I have tried to tell their tale, recounting the turmoil of their daily existence, endless battles laced with moments of grace.

For the past three decades, my job as a reporter has led me to photograph several women who have ascended to power, such as Benazir Bhutto, Cory Aquino, Winnie Mandela, and Indira Gandhi, but I have also followed the lives of less heralded women: anonymous women fighting in Mesopotamia, female Afghan refugees traveling in caravans on the road to exile, Rwandan mothers desperately looking for their lost children.

My images aim to show the grace of these women's lives, beyond their struggle to survive.

When Benazir Bhutto returned from exile in 1985, I accompanied her and photographed her as she rose to victory in Pakistan, becoming the first woman to be democratically elected as the head of a Muslim country. The day after her election, I went on my way. I was not the man for the arcane dealings of power. At her side during her campaign, I knew the virus of power could transform this charismatic fighter, and might corrupt her and make her betray her ideals.

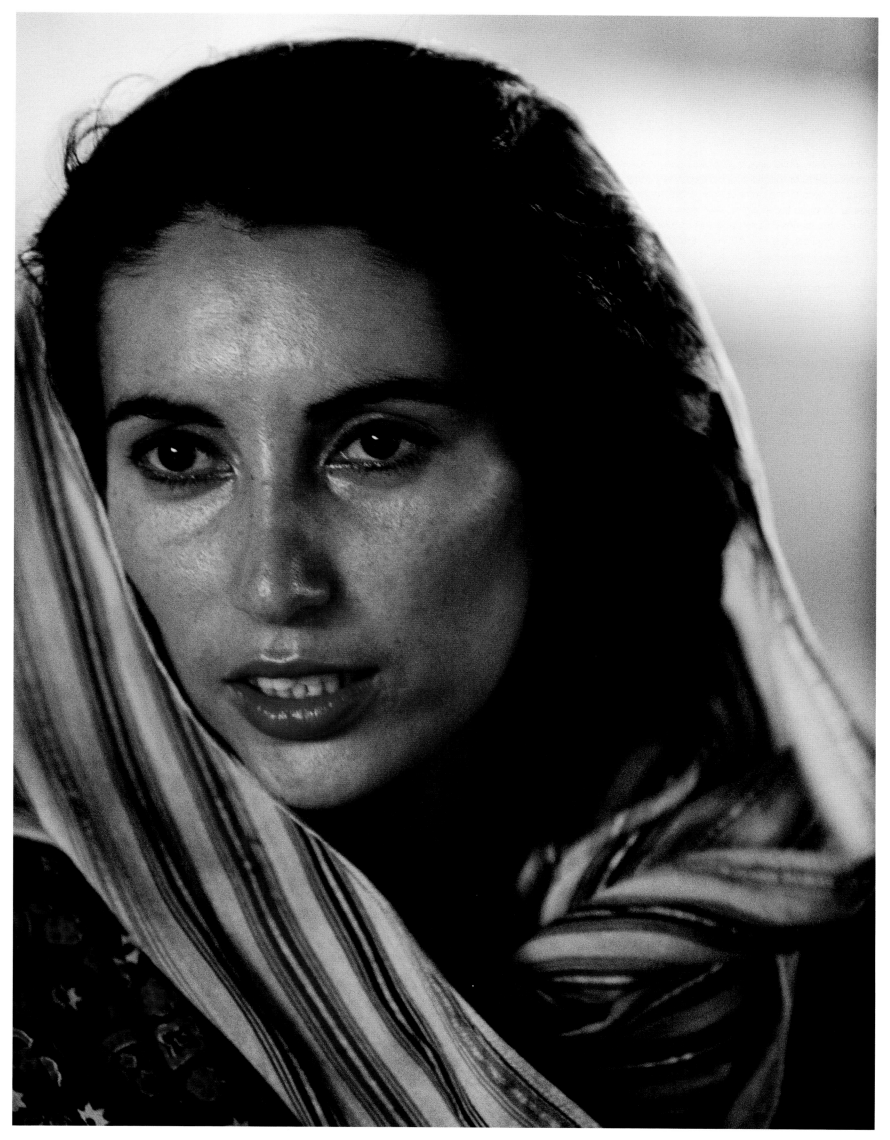

Pakistan is divided into four large regions: Baluchistan, Sindh, the Punjab, and the land of the Pashtun. Each of these regions is ruled by landowning families, many of which are striving for control over the country. Benazir Bhutto's family, which comes from the province of Sindh, has paid heavily for its accession to power. Bhutto's father, Zulfikar Ali Bhutto, was hung by General Zia Ul Haq, and her two brothers, Murtaza Bhutto and Shahnawaz Bhutto, were murdered. In 2007, after returning home after a long exile, she herself became the victim of assassination.

I took this photo in 1986. She was in the middle of her election campaign. Jubilant people were throwing rose petals at her as her convertible drove by. Smiling and waving, she was overjoyed by the hope she inspired in them. More than 20 years later, I look at this photograph and think of her assassination. She was again campaigning for office. On the day she died, Benazir Bhutto was also amid an adoring crowd, waving to people who had come out to cheer for her. Then the bomb exploded. The rose petals of the photo I took in 1986 make me contemplate that scene, imagining the drops of blood that must have sprung from her at the moment of the explosion.

Standing alone and upright, Prime Minister Indira Gandhi seemed to be in front of a firing squad composed of Sikhs. The men were her personal bodyguards. A prophetic image? The time had not yet come, however, for her tragic end. Instead, on that March day, the leader of the Indian subcontinent was about to welcome the heads of state who had come to take part in a summit of nonaligned countries.

Yet, a year later, it was Sikh extremists who killed her. Gandhi was felled by the bullets of two of her Sikh bodyguards. They carried out her assassination because of her government's repression against Sikh separatists. Photojournalists often develop a sixth sense about danger, sometimes knowing that they are in trouble without necessarily being conscious of it. The unique situations we face sharpen this sense, which is ineffable, deep-seated, and purely intuitive. It helps us avoid danger when we flirt with death. And it is also this intuition that sometimes helps us capture images that later, in the light of subsequent events, come to take on their full significance.

Benigno Aquino, the most prominent opponent of President Ferdinand Marcos and his 20-year reign of terror, returned from exile in 1983. As he came down the stairs of the aircraft, a military escort shot him in the head. It was a premeditated assassination ordered by the Marcos regime. Pictures of his lifeless body sprawled on the tarmac, his head bathed in blood, traveled around the world. The murder of Aquino, a champion of democracy for the Philippines, marked the beginning of an uprising that would topple the Marcos government. Aquino knew he was destined to die, but no doubt hoped that by sacrificing his life, he could unite his countrymen. Trusted by the people, his widow, Cory Aquino, entered the political fray to carry on her husband's work. She led the victorious People Power Revolution, symbolized by the color yellow. The sound of chants and marches rang throughout the country as citizens gathered in peaceful protest against the government.

On February 22, 1986, three days before the fall of Marcos, the soldiers of a large barracks rebelled against his dictatorship. Pressed behind metal railings, a crowd congregates in watchful support.

AZERBAIJAN | *1990*

AZERBAIJAN | *1992*

Opposite: The Afghan resistance dealt the Russian Empire a fatal blow. One of the world's greatest armies had surrendered after ten years of fighting the warlords in the mountains. The dismantling of the Eastern Bloc had begun—a process symbolized by the first chunk of concrete torn down from the Berlin Wall.

In Azerbaijan, a country under Russian control since the 19th century, political unrest grew into a revolt against the Kremlin. To punish this audacity, Russian tanks entered the capital city of Baku on the night between January 19 and 20, 1990, firing machine guns. The massacre left hundreds of dead and wounded. The city was closed to journalists. But I managed to get there by taking a train from Moscow, keeping myself concealed during the 48-hour trip. I was able to provide a visual testimony of the Russians' violent supression of this uprising. I took some of the photographs through the windows of unmarked police cars.

Above: The small town of Khojali was the site of a massacre by Armenian troops in February 1992. Only a few of the townspeople escaped the slaughter. Those who survived would go to the morgue in the city of Agdam, looking for a family member who had disappeared, each day wandering among dozens and dozens of corpses wrapped in white plastic. Slowly, carefully, they examined each face, one after the other, discovering the horrors perpetrated by the Armenian soldiers. This woman had just found her son and husband. Their eyes had been torn out while they were still alive, according to the doctor who was assisting her in her search.

I can still hear the unbearable anguish of her wails.

FRANCE | *1990*

AFGHANISTAN | *1990*

In the decade since I had gone into exile, I had covered wars and uprisings in the four corners of the world. Those ten years were also a time of separation, as my relatives were still in Iran. I was anxious about them. The country was at war, and their daily lives were full of affliction: death, imprisonment, fear, disease. Their suffering resonated with me. I was devoting my life to bearing witness, through my camera, to the struggles and hopes of so many other oppressed peoples around the globe, and therefore knew intimately how difficult life had to be for them.

Now, after this solitary and challenging decade, came the troubling, heartrending, and magical years—the turning point in my life. I had met Rachel, who was to become my life's companion. My mother had come to France to visit me, to visit us. Rachel and my mother didn't share a common language, but they had found a way to communicate, conveying through their facial expressions, and through small, thoughtful gestures, their mutual respect for one

another. And then, as my mother was undergoing a routine medical exam to monitor her tired, aging heart, she passed away—maybe, I hope, at peace, knowing that I was not traveling the lonely road of exile alone. The time had come to mourn as one does in the Middle East: a time for wearing black, for weeping, for sharing sadness with friends. Seeking refuge, Rachel and I left Paris to go to the Camargue, Rachel's native region in the south of France. I took her photograph as she slept in a field of poppies.

A short time later, I went on a humanitarian mission to Afghanistan, working on behalf of the United Nations. The Afghans had just come out of a war that had lasted for ten years. I traveled to the remote Badakhshan Mountains to provide assistance, and temporarily put aside my cameras and my life as a photojournalist. I stayed there for nine months. By the time I left, I felt renewed, reborn as a new me, and I found Rachel again.

White doves flew into the esplanade in front of the blue-tiled mosque, reclaiming their rightful place now that the festivities of Nowruz were over. The ancient New Year's Day celebration, which occurs on the first day of spring, had come to an end. The crowd had left. Those who had danced themselves into a trance had also gone home.

Calm had returned to the esplanade. At dawn, all was silent. The doves seemed to be the only witnesses to a strange ritual (page 81): A solitary woman, completely veiled by her golden chadri, as the chador is called in Afghanistan, was walking around and around the Blue Mosque. According to tradition, if a woman walks around the mosque at dawn 40 times for 40 days, she can guarantee her fertility.

Mazar-e Sharif is the most important pilgrimage site in Afghanistan. The war with the Russians, followed by years of fratricidal conflicts, had prevented Afghans from coming to the mosque, thought to contain the tomb of Ali, the son-in-law of the Prophet Muhammad. But the fall of the Taliban regime marked the start of pilgrimages to this sacred site again.

The white doves flocked to the square, inspiring me to dream, for an instant, of an Afghanistan at peace.

Buzkashi has been played in northern Afghanistan since the Zoroastrian era more than 2,000 years ago. A master of ceremonies, the *buzkashi rais*, is the referee. A goat serves as the ball. The night before the game starts, the goat's throat is slit. The goat's headless carcass is placed in the "holy circle," a circle in the middle of the field. To win the game, a player has to grab the goat's body by the leg, ride around the field holding it with his arm outstretched, and put it back in the center of the circle.

It is a brutal, fast-paced game. I associate the game's jumble of men and horses with Picasso's "Guernica" and with the intense emotions the painting provoked in me the first time I saw it. I was studying architecture, and our professor of modern art history introduced my classmates and me to this magisterial work. A tapestry of the painting, which has become an emblematic image of the horrors of war, hangs imposingly at the entrance to the Security Council of the United Nations.

After ten years of fighting the Russian Army, the Afghan resistance had forced the occupiers to retreat. But Afghanistan was a devastated country. Its towns, villages, and infrastructure had been destroyed. Five million people had fled, becoming refugees in Pakistan, Tajikistan, and Iran. Mines littered the fields. Battered from years of war, the Afghans were grieving over their dead and injured, and had become even more divided by ethnic conflicts.

In May 1989, Prince Sadruddin Agha Khan, the coordinator for the United Nations' humanitarian aid effort for Afghanistan, offered me a six-week photo assignment in Afghanistan on behalf of the UN. At the end of the first month, he asked me to become a consultant in the country's northern provinces. My task was to help open the roads for the relief shipments of wheat arriving from Termiz, in Uzbekistan. For nine months, I put my cameras aside to do this relief work, which I considered a more concrete way to help the Afghans than photojournalism.

On the world stage, one human crisis follows another. The winter of 1991 was marked by the Gulf War and the exodus of millions of Iraqi Kurds. My mission in Afghanistan had come to an end. The United Nations in Geneva asked me to become a consultant in Kurdistan. At the same time *National Geographic* offered me a story assignment on Cairo. So I faced a dilemma: whether to pursue my career as a photojournalist and continue to be a witness, or become a humanitarian worker. The words of an official at the United Nations clinched my decision: "Your photographs are the reason why we're so drawn to Afghanistan." If my photos had been able to make such a strong impression on this man, who, through his role at the UN, could help improve people's lives, then I owed it to myself to pursue this line of work. As a witness, I could make a difference.

In 2001, a year of major upheavals in the world, I founded Aina, the Afghan Media and Culture Center. A nonprofit organization devoted to developing a free press in Afghanistan, it helps ensure that journalists, intellectuals, and artists can speak freely, provides training in media and communications for women, and offers educational programs for children.

The builders of millennia. Nine years old, he spends 12 hours a day making and carrying pottery. He toils in a makeshift workshop, a shed with walls covered in thick, black soot. The fuel used to heat the kilns comes from Cairo's trash. He inhales the fumes for days, years on end. He sees nothing all day except the dark and dirty walls, the dizzying spin of the potter's wheel, and the clay that he pulls up from the wheel, stretching and shaping it until it is transformed.

How many are there of these "children of the South" — these underage workers who spend their days holed up in workshops and factories in order to make consumer goods to satisfy Western markets?

The list of products they make with their small, nimble hands is lengthy, and it includes dolls, sneakers, and clothes. The children have to work to help feed their families. Child labor sometimes ensures a precarious financial stability in countries whose economies are in peril, but mostly it benefits multinational corporations, which profit from such cheap labor.

Looking at the images of these children, whose futures are so blighted, leads me to the sad reflection that they are less the "builders of the third millennium" than the "slaves of the third millennium." The Egyptian people, the proud heirs of ancestors who left us the Pyramids as evidence of their genius and resolve, today oscillate between misery and serenity, living a life of toil but approaching it with apparent nonchalance — a people who, it seems to me, are traveling through history with a spirit of grandeur and decadence.

EGYPT | *1991*

EGYPT | *2000, pyramid of Khafre*

Central Cairo is a teeming, noisy place, busy day and night. Muslim pilgrims come from all over the world to Al-Azhar Mosque, one of the oldest universities in the world, to meditate and study. In the adjoining Al-Hussein Square, beggars, passersby, believers, and tourists weave past one another in a strange ballet.

The oppressive heat and congestion of Cairo often disorient people. Among the few places of refuge here in the center of the city are Al-Hussein Mosque and the famous Al-Azhar Mosque, a street away. The West tends to think of a mosque as being the image of a militant Islam. Yet any curious but respectful traveler who enters a mosque outside of the hours of prayer will be struck by the serenity that emanates from it. Those who go there for a pause from the hurry of their daily lives will share a moment of calm in the home of a tolerant God, who will meet their expectations, whatever they are. And those who are weary in body and soul will find a haven of peace.

Often, a mosque will have a jar full of fresh water available to quench a worshipper's thirst.

Above all, a mosque is a place of vibrant life. In Al-Azhar, one man has fallen asleep on the carpets that cover the floor. Another murmurs his prayers, prayer beads in hand. By a window, a group of students are quietly going over their lessons. Behind the curtain, a woman is reading the Koran, open on a book-rest, while another nurses her baby.

He is from here and from there, from the East and
from the West. Since he was a little child, my son,
Delazad, has traveled around the world, sometimes
sharing my life as a photojournalist. Whether traveling
with our family or alone with me, he was eager for
discovery, entering fully into our adventures, like a
dervish looking for knowledge. As a baby, he used to
fall asleep to the sound of troubadours while I was
on assignment by the Caspian Sea.

As a boy, he rode his scooter down the streets
of Paris, Rollerbladed through New York, went on
horseback in Libya. Crossing the Bosporus, he
watched as seagulls flew in the sky, melding with the
minarets. Dressed like an Egyptian child of the past,
he played with the lights of a traditional house in Cairo,
stepping on the patches of light. Later, when he was
older, he drew a map of an imaginary subway for
Kabul. Through these experiences, he has savored
life, learned, seen, and felt. The world has become his
school, his home. Like him, his friends are from here
and from there, from the East and from the West.

When my son was seven days old, an old man
whispered in his ear, "Your name will be Delazad,
which means 'free soul.'" A few years later, the name
Djanan was whispered in his sister's ear, a name
that means "breath of life." From these first, secret
whisperings, I hope that they will live by the idea of
building a world that is open and expansive, without
borders and without wars.

A crowd of pilgrims swarms into the huge esplanade that stretches in front of the mosque of the city of Tanta. They are arriving for Ragabiya, a three-day festival in honor of the most venerated saint in Egypt, Sidi Ahmad Al-Badawi. The worshippers celebrate his memory to the rhythm of tambourines and Sufi chants, music so hypnotic some of the pilgrims dance themselves into a trance. Despite the hardships of their daily lives, Egyptians know how to be joyful. Egypt has many such lively religious gatherings, called *mulids,* where people come together to celebrate the birthday of a saint. I stayed at the festival for all three days, remaining right at the heart of it: I was at the feet of the dancers, shooting from down on the ground, trying to capture the instant, the very moment of truth. Being patient, staying right in the thick of wars, celebrations, tears, screams, the core events of life, and becoming nothing but a visual resonance chamber—that is my role.

EGYPT | *1991*

EGYPT | *1991*

Each day, as the sun makes its slow arc over Cairo, the level of noise grows louder by the hour. Every single neighborhood is crowded with people, some loitering or moving with relaxed nonchalance, others frantically hurrying. The city is packed so densely that squatters have taken over the cemeteries on the city's eastern edge. In the City of the Dead, they have erected homes and shops among the tombs, amid the silence of the dead. Although they are asserting the rights of the living, they show consideration for the tombs, living in respectful cohabitation with the dead.

By nightfall, the city comes fully alive, particularly during the mulids, the merry and noisy celebrations in honor of a saint.

While walking through the city at night, I make out the sound of some drums and the daf, a large drum. The percussive instruments are marking a regular and frantic rhythm. Somewhere in the maze of dark alleys, some Sufis must be playing. I come closer. I can hear their voices now, low and bursting forth from the depths of their bodies and souls. I come closer still. There they are, wearing their long, white tunics, which stand out against the red decorations for the mulid. Their heads move in harmony with the music. Their faces are covered with sweat. Their eyes close. They go into a trance.

From the whirling dervishes in Turkey to the ritual dancers in Africa, worshippers often enter into a state of rapture to commune with God. As they dance, the men chant, reciting poems by the 13th-century Persian poet and philosopher Djalal Al-Din Rumi, also known as Mowlana.

In the early morning, as the Cairo muezzins call the faithful to prayer, the dervishes strike their drums one last time. The men turn inward, exhausted after the divine drunkenness of the long hours of the night.

In Cairo, amid the rhythmic comings and goings of the traditional feluccas and the stately cruise ships are the true masters of the Nile: the thousands of people who live on rowboats—their home, their refuge, their workplace, and their means of transportation. Before dawn, before the call to prayer from the city's minarets, they row their boats out from the river's banks, plowing silently through the water on their way to fish for the day.

Two of these fisherfolk, Mahmud, and his wife, Om Sara, have set out on the river. Om Sara rows the boat, her four-month-old baby at her feet. Her two other children are still asleep in the hull. Mahmud throws in the fishnets, hoping that today's catch will be good. If it is, he will go to the market to sell the fish, while she will gather the nets, fix the family's only meal for the day, and wash their clothes in the water of the Nile. The two older children wake up, roused by the first rays of the sun. They play quietly aboard the rowboat, unaware of the pollution that surrounds them. For them, the river is a fine setting for their games.

The catch is plentiful. Mahmud returns from the market in the crushing heat of the afternoon. The family gets busy tending to their fishnets, their survival tool. They check the nets meticulously, mending any holes. At twilight, they curl up against one another to go to sleep. Om Sara and her husband close their eyes, eager to shut out the sight of the opulent hotels and villas that dominate the riverfront. The other families on the rowboats have also turned in for the night. The Nile falls silent.

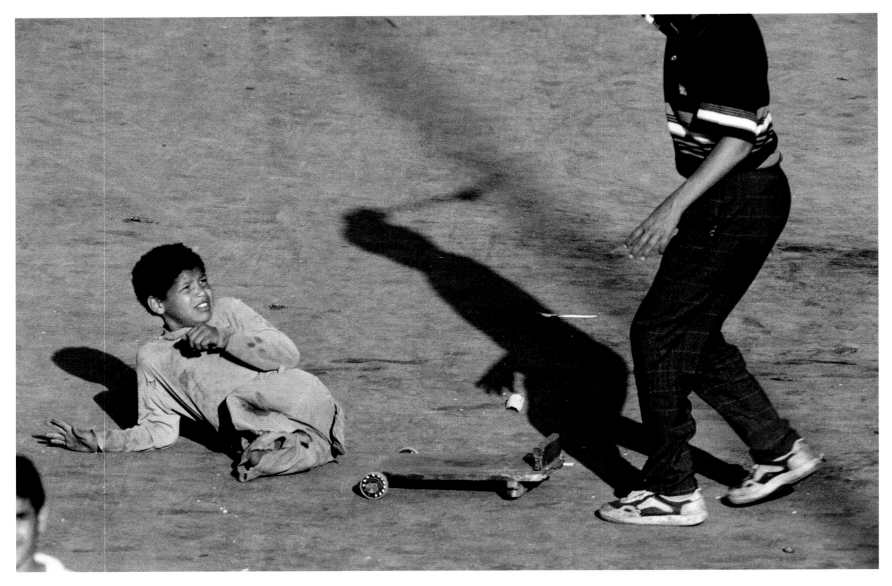

EGYPT | *1991*

Above: Beggars congregate in public squares and other places popular with Cairo's tourists. Lying on his skateboard, which serves as his legs, Saed spends the day begging, sometimes stopping to play a game of soccer with his companions in misfortune. He lost his legs after being run over by a train. He had jumped on the train for a free ride because he had no money to pay the ticket. Now a lonely little boy, he'd had to go out on his own after the accident and had joined a team of beggars, a small group of boys ruled by a teenager who guarded their turf and took a share of their earnings. The teenager, whose shadow looms over Saed, was coming to whip Saed with his belt, accusing him of not working hard enough.

Opposite: For me, the neighborhood of Al-Hussein and the area around the medieval gate of Bab Zuweila are the heart of Cairo. At set times of the day, a muezzin calls the people to prayer from Al-Hussein Mosque and from Al-Azhar Mosque nearby. The call mingles with the smooth, repetitive melodies of the romantic chants sung by the diva of the Arab world, Om Kalsoum, and with the throbbing sound of the latest hits.

If you let yourself be guided by the thundering music, you will enter another world, hidden away from the sunlight and the heat: the famous Al-Khalili covered bazaar, where, exhausted from your adventure, you can collapse into one of the welcoming chairs of the café Al-Fishawi. There, like any worthy Egyptian, you order a narghile and some tea, then spend hours watching the passersby or deep in your own thoughts. The café, located right in the middle of the bazaar, is more than a picturesque place; it's an institution. From this ideal observation post, you can let yourself be taken over by the strange serenity of the surroundings—an atmosphere no Egyptian who comes to this place would pass up on any account. Lulled by Om Kalsoum's soothing love songs, I felt at peace. In the air, I smelled the sweet fragrance of jasmine. Then, despite the noise, I heard a foot drag across the floor, a sound accompanied by the tapping of a crutch. Through the voluptuous curls of smoke from my narghile, I saw the beauty of Leila, the jasmine vendor.

EGYPT | *1996*

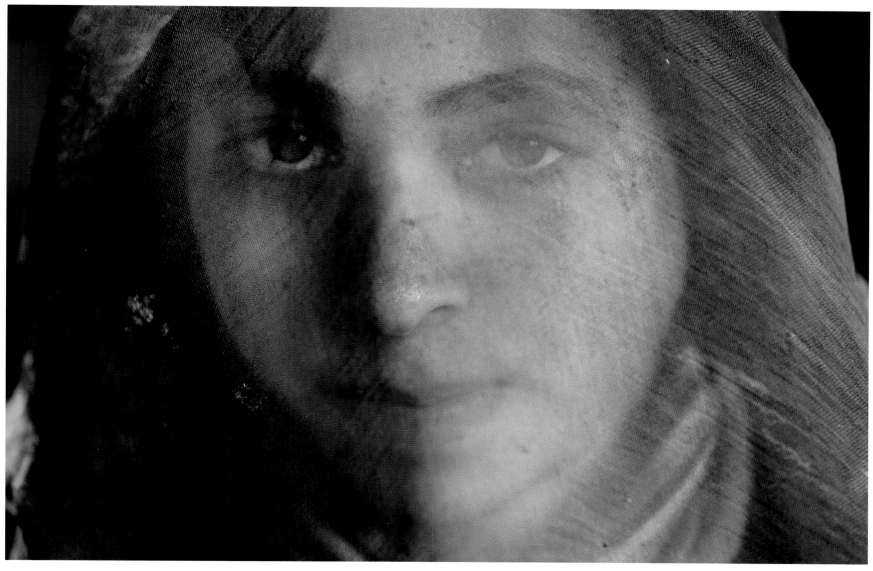

EGYPT | *1996*

A light veil protects the beautiful face of Sabah, who is 15, from the dirt, the dust, and the sunlight. She works in a brick factory in the Nile Delta. Instead of going to school, Sabah carries heavy bricks stacked on a wooden board propped on her head, working all day without any respite from the sun or the heat of the brickyard's furnace.

Though vast, Egypt has little arable land. The Nile's irrigated banks account for just 5 percent of the surface of the country. The rest is desert. Before the rise of the tourism industry in the past century, agriculture was the nation's only resource. Overpopulation and increasing urbanization in the Nile Delta have significantly reduced the amount of

land that can be cultivated. A vicious circle set in: in order to have a roof over their heads, people used the Nile's rich soil to build bricks for their homes; Egypt's fertile earth, its most precious asset, shrank away. Responding to this alarming situation, the government took action. Lawmakers banned the use of crop soil for construction and also launched major projects to tame the desert and turn it into farmland. As of today, however, these projects have proved costly and not very effective.

When I saw the majesty of the Pyramids for the first time, I was both intrigued and dazzled. The Pyramids were built so long ago that I had a hard time imagining what daily life was like then. How could such an ancient civilization, without the benefit of modern technology, build temples, pyramids, and such imposing statues as the Sphinx?

As a child, I liked to pretend I could travel through time and visit another century, another reality. During these imaginary voyages, I was everything all at once—I was both the actor and the spectator, the slave and the pharaoh, and I was the tale-teller, too. In *Traveling Man: The Journey of Ibn Battuta, 1325–1354*, James Rumford writes: "Traveling leaves you speechless, then turns you into a storyteller." I undoubtedly began my life as a nomad thanks to my imagination. Later, as an adult, I chose photography as a way to tell stories.

In this rice field of the Nile Delta, the sun was unsparing. It beat down on Muhammad, his daughter, and his niece as they tried to clear budding rice sprouts from the mud. As I watched them, I suddenly understood how the Pyramids were built. I saw the thousands of Egyptian men, long ago, who constructed those towering buildings using only the strength of their backs and arms.

A shattered culture. Fires are crackling in the sad and icy street, still freezing on this March day at the end of winter. It rained yesterday. The dirt roads are only mud now. The mud splatters the long, swinging skirts of the women and girls, and the boys' threadbare pants; the children are not covered up enough—their lack of warm clothing is the dress of destitution. The smell of burning tires spreads over the city of Cizre. The children, excited, jump and dance. They could almost laugh wildly and crazily, with carefree abandon. But their elation is fleeting. Turkish armored tanks are advancing on the city. Panic sets in. Some children run home. Others stay, drawn by the flares of the bonfires, held captive by the sad joy of their blaze. Mothers beg the soldiers for restraint. They make their plea standing in front of the tank artillery pointed at them.

Present-day Turkey is all that is left of the Ottoman Empire. Founded by Turkic tribes from Central Asia, the empire was broken up by the Western powers at the end of World War I into Turkey, Syria, and Iraq. The areas that had belonged to the Armenians and the Kurds were supposed to be returned to them, but Mustafa Kemal, known as Atatürk, the "father of the Turks," led bloody battles to quash every attempt at independence. Since that time, the Turkish government has continued to suppress the Kurds' cultural identity. Without achieving a political and social resolution to the Kurdish problem, however, Turkey will not be able to claim a strong role on the international scene.

On this cold March day, the eyes of the children in Cizre betray their weariness and incomprehension.

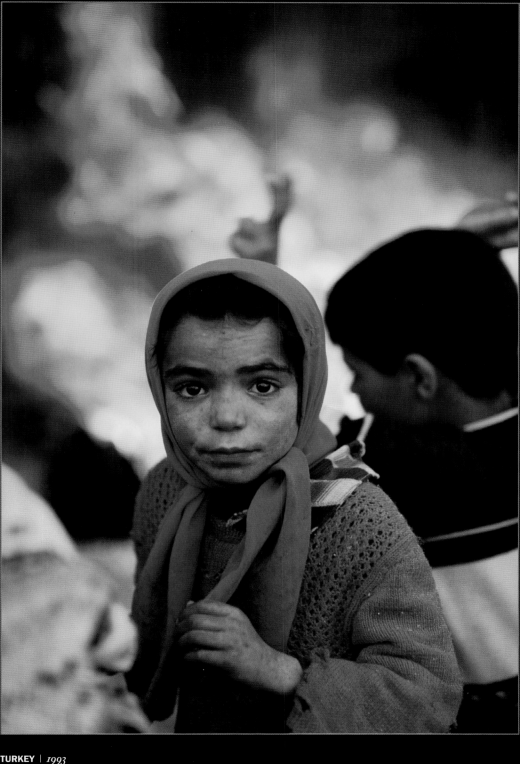

The sky tore apart suddenly, disrupting the calm of the evening and putting a stop, as well, to the busy, teeming noise of Istanbul. For a moment, the Bosporus—the place where the Black Sea and the Mediterranean, and Asia and Europe, all meet—came to a standstill, a brief, stunned halt before the wrath from the gods of rain bore down on it. The city of Istanbul, too, came to a stop for an instant. The Bosporus Bridge crosses the strait, linking both sides of Istanbul, and also both continents, the East and the West. Battered by the storm, the friendship bridge seemed fragile.

At the heart of human history, the Bosporus has always been the scene where empires were made and unmade: the site for the confrontation between the Persians and the Greeks; the route for the Crusaders, surging toward the East, driven by the thirst for conquest; and the setting, on the heights of Istanbul, for the Palace of Topkapi, from which the Ottoman emperors ruled over the world for five centuries.

While covering various stories in Turkey, I witnessed the richness and the fractures of the country's culture, both the result of the tension between modernization and tradition, between East and West.

TURKEY | *1993, tracer bullets seen from my hotel window in Cizre*

Celebrating the new year on March 21 dates back to Zoroastrianism, an ancient religion whose followers worshipped fire. A tradition from this long-ago religion still survives in a vast area that covers Afghanistan, Central Asia, Kurdistan, India, and Iran. The last Tuesday before the new year, people light bonfires on the streets, in their gardens, and at the major intersections of cities and towns. Each person has to jump over a fire to be purified of the year that has come to an end and to prepare to enter the new year. In Iran, this rite from ancient Persia still persists. In Turkish Kurdistan, it continues to be celebrated as well. But each year, March 21 turns into a riot there, as has happened in other countries where invaders or central governments have tried to forbid this cultural ritual in order to erase a group's identity. Children dance around the fires, but far from exhibiting the lighthearted mood of a festival, they are already animated by a spirit of revolt.

TURKEY | *1993*

At the crossroads of cultures, social strata, and religions, Istanbul—formerly Constantinople—is a permanent invitation for exploration and discovery. The world capital of the Ottoman Empire, Istanbul has preserved the magnificence of those past centuries, visible in the splendor of the Palace of Topkapi; the mosques designed by the architect Mimar Sinan, with their elegant minarets; and the princely palaces that once welcomed European travelers who arrived from Paris on the *Orient Express.*

But beyond these dazzling sights, there is also another Istanbul, a city with dark alleys, tiny shops from a bygone era, wooden houses, the labyrinths of the Grand Bazaar, itinerant peddlers, and bear trainers. And on the Bosporus, there is the synchronized dance

of the boats that travel between the two banks of the strait, transporting people who, during the length of the crossing, are inspired to dream by the scenery. Each photo assignment here is a plunge into all of the layers of the city's society. In the conservative, working-class neighborhood of the Eyüp Sultan Mosque, modern Istanbul seems very far away. The mosque is on the shores of the Golden Horn and attracts pilgrims. Fervent believers, they hurry in for Friday prayers. In front of the mosque, children chase pigeons and play with balloons. From time to time, luxury cars pull up nearby and stop at the door of a shop with dirty windows. Behind the glass panes lie objects covered with dust as old as the shop's owner. The door to the shop seems closed. Women from the modern sections of Istanbul step out from the cars. Scantily dressed, they are very different from the

women in the neighborhood, whose heads are covered by a veil and whose bodies are hidden by a long coat. When the door to the store opens, they hurry furtively into the shop. Each waits patiently for her turn to go in. The old man who runs the shop is so old he has become ageless. But he is still powerful. He commands the ability to make predictions and, with his magic herbs, heal the most serious of ailments and help realize the most improbable of dreams. Magic potion in hand, the women leave the shop and drive back in their flashy cars to their contemporary, expensive homes on the shores of the Bosporus.

Istanbul is searching for itself, tugged between modernity and tradition.

In the early 20th century, the Ottoman Empire, which had shone as the dominant power in the region for centuries, saw its area of influence shrink as foreign armies occupied its territory. The romantic splendors of the East, which had led to the Ottoman supremacy, drew back before the West and its race for modernization. Mustafa Kemal Pasha, later known as Atatürk, was at that time a young officer in the Ottoman army. A man with a clear, steely gaze, and a cold and determined expression, he was a nationalist who rebelled against his country's withdrawal as a player on the international chessboard. He led a war of independence against the occupying forces. In 1923, he established the Republic of Turkey, drawing up the country's current borders. Conscious that the country needed to modernize, he guided its foundation as a secular state, which today can lay claim to its role, in the 21st century, as a mediator between Europe and Asia, between East and West. But in Turkey two currents of thought have continued to oppose one another: those who defend traditions and those who support modernization. The nation's rapid modernization, however, has led to an enormous gap between a wealthy minority, made up of people who are newly rich, and the rest of the population.

In recent elections, the rise of the Islamist Party has highlighted the return to religious values among the Turkish people, as well as their denunciation of the excesses of the well-off.

TURKEY | *1993*

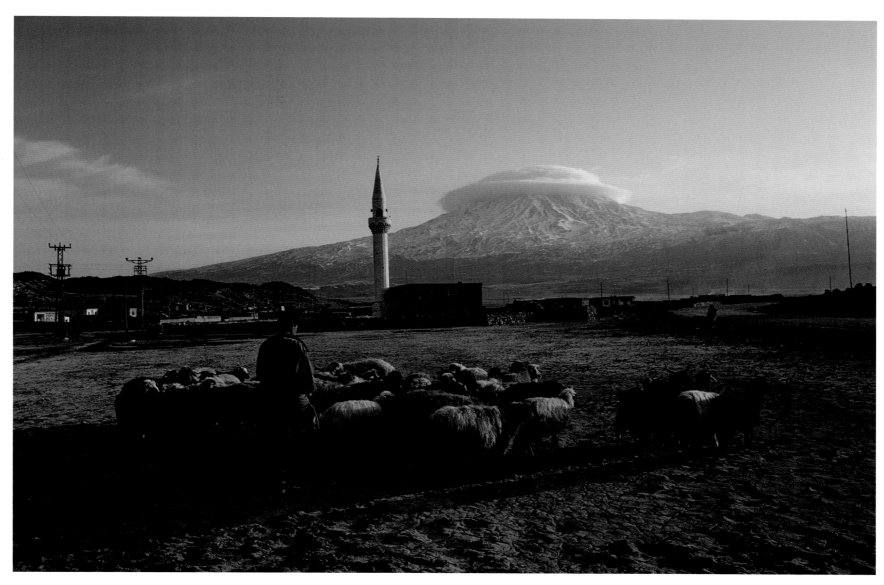

TURKEY | *1993*

Though he died long ago, the mystic poet Hajji Bektash Veli still inspires pilgrims to gather in his native town, not far from the lunar landscapes of Cappadocia. A wishing tree stands near the Sufi's mausoleum. Tens of thousands of pilgrims arrive in August for an annual festival in his honor. With a fervor that has never dimmed through the centuries, they pray, weep, and dance for several days. At the tree, they ask that their prayers be granted. The sacred mulberry tree offers to the wind pieces of fabric, traces of secrets, and wishes tied on its branches.

Farther to the East, at the door of ancient Persia, Mount Ararat towers above the crossroads of the ancient empires of the past. In this region of Turkey, life is rural and follows the rhythm of the seasons. For an instant, the peak of Mount Ararat, said to be where Noah's ark ran aground, is capped by a dome of clouds, lasting just long enough for a photo.

TURKEY | *1993, Kurdish cemetery*

Memories of childhood. The memories of my peaceful childhood are from long ago. They belong to another life. + When I was small, I lived in Tabriz, where people spoke Azeri and Persian. It was very cold there in winter, so cold that laundry drying outside would become hard, like dry wood. When March arrived, the snow would melt. Buds would start to decorate the tree branches. Aroused by the sunlight, nature would be reborn, and up above, swallows would swoop through the air, their bodies small, twirling black spots against the blue sky of Tabriz. + To prepare for the start of the new year, every corner of the house had to be scrubbed down. Washed, our house's colorful rugs, with their magnificent designs, would be hung out in the garden to dry. The vernal equinox marks the feast of Nowruz, New Year's Day in Iran. To celebrate the feast, we would go catch a goldfish from the pond and bring it into the house, placing it on the Haft Sin table, a table especially decorated for the holiday. A few days before March 21, we would go to the bazaar with our parents. I still remember the rich colors of the mountains of spices that brightened the city's dark maze of covered alleys. Every year, we would wait with impatience for this time, when we would get new clothes and the house would overflow with cakes, fruit, and candies. On March 21, we would sometimes be awakened in the middle of the night: The fateful hour was near. Our entire family would gather around the Haft Sin table, on which our mother had carefully prepared seven ingredients that start with the letter "s" in Farsi. The moment the goldfish wiggled in its bowl, we knew that we had entered a new solar year. Then we had 13 days of celebration, during which we would go visit other people's homes, and guests came to our house. Out of respect, young people would call on their elders, visiting them first. The tablecloth was spread right on the floor. Everybody sat on cushions. + We children would play in the garden and run around the house, racing with our cousins. The holiday was a time to reunite with friends and extended family—the idea of family has always been very important in Iran, as in most countries in the Middle East. New Year's was a time for celebration, renewal, spring. + Thirty years later, I was in Turkey during the month of March. I had already spent several months in the country, wandering around in a culture so close to mine that many of its sights echoed my childhood in Iran. I wanted to gaze at Iran from the border, even from a distance, to touch and stroke it with my hand. I knew that thousands of Iranians had fled the repression of the mullahs' regime, by crossing into Turkey near this border. As for me, it had been years since I had last seen Iran. But like a meeting that is both desired and feared, I would put off my visit each day. Then came the day. Bravely and without stopping to think, I set forth. As I reached the town of Dogubayazit, my heart began to pound. I was very near the mountain on the Iranian border now. And as I rounded the curve of a small alley that opened out onto a large, flat stretch of land, there it was, towering above the plain, proud and immovable. Its peaks and slopes looked like those I had seen from Iran. But maybe something was missing, some critical detail that would put the finishing touch to my visual reunion with this mountain that dominated the border. Suddenly, I saw them. Two boys passed by, holding a hollow television set. In them, I saw my brother, Manoocher, and me, when we were children, accomplices in our games as in the dreams we had for our future. + Manoocher and I share the same passion for acting as witness, using our cameras to record wars, conflicts, and other disturbing world events. In the name of that passion, we both took the road of exile.

TURKEY | *1993*

SARAJEVO | *1993*

SARAJEVO | *1993*

Opposite: The air was chilly. Sarajevo, besieged, had only occasional respites from the bombing. Then the city could breathe again. Every once in a while, the deserted streets would come alive as somebody would run wildly down the street, risking his or her life for a little water or a loaf of bread, racing to avoid snipers.

A touch of color amid the cold dreariness of war, she stood without moving or speaking. She was selling her toys, the testimony of a ruined life. I felt quite helpless in the face of such human injustice, which had forced a little girl to sell her dearest possessions, the companions of her childhood.

Above: The war-ravaged ruins of Dezful, Tehran, Beirut, Kabul, Sarajevo, Sanandaj, and Abadan, as well as of many other, lesser-known cities and villages, testify to a past that has been laid to waste. In every war, the participants try to obliterate every trace of their enemy, as if by destroying their enemy's buildings and monuments, they can kill the past and thereby appropriate the future for themselves.

Africa's lament. Wrapped in her shawl, she looked like a queen. Its warm, bright colors pulsated with life, in contrast to her surroundings. Everything around her was somber and mournful. With a proud bearing, she walked toward her small house of gray clay. I read, in her beautiful, emaciated face, Africa's wounded history. Africa, too, is like a weary queen in her finery. Over the centuries, the continent has seen its lands conquered and its people enchained. Violence, apartheid, famines, tribal wars stirred up to serve foreign interests—Africa has been the stage for distress and lamentation, endured with dignity. Faced with indifference from the rest of the world or, sometimes, an overly intrusive humanitarian solicitude, Africa has been trying to raise itself back up again after centuries of colonial occupation. And it remains a victim of the wealth of its soil, coveted first by the foreigners from the north, and now by Asia.

Starvation is still prevalent in many parts of Africa. A gaunt child rests her head on her knees, her head far too heavy for her body, now a skeleton. It is the silent appeal of these images of starving children that must resonate within us, drawing our empathy, an understanding for their plight that goes beyond pity and efforts at assistance.

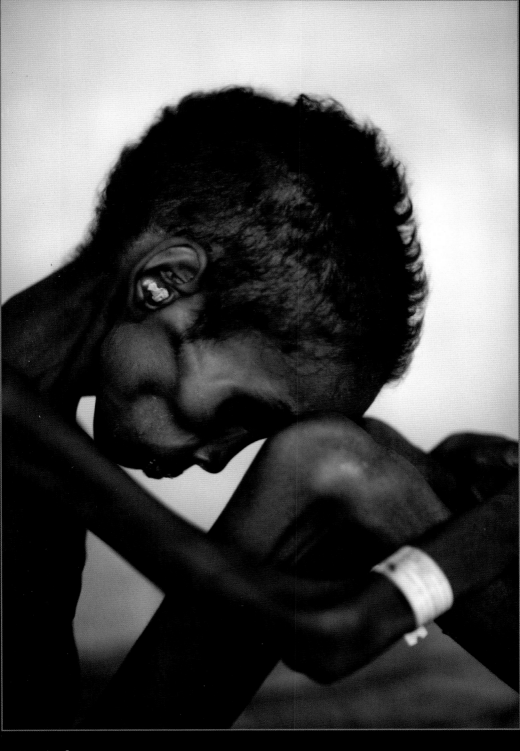

I saw his feet, scarred by chains that also bound his hands. His eyes were resigned, his violence contained. He evoked the image of another time, the days when his ancestors were seen by white people as nothing but a kind of currency to be traded.

As far as the eye could see, tents dotted the immense plain of red earth. Each blue dot housed a fragile household, the survivors of an ethnic conflict between the Hutu and the Tutsi tribes. Like shipwrecked people on a raft, the refugees clung to their tents, which offered them a haven and a hope of survival after the bloodshed. They lived remembering the hell they had escaped, haunted by the horrors they had seen: machete blows, blood, terror, wounded flesh, beheaded bodies. The threat of attack was not over. Violence lurked despite the seeming peacefulness of the landscape.

Massacres kept happening, even inside churches, where people sought sanctuary only to be locked inside and burned alive. The refugees in the camps had a wounded, sometimes vengeful look. The people who wanted revenge had a crazed expression in their eyes. But for those who had died, screaming, in the churches, nothing of their faces or personalities was left. Of them, only a pile of bones and skulls remained.

RWANDA | *1996, after the genocide*

Preceding pages and opposite: In Rwanda and neighboring Burundi, the members of the Hutu tribe are the main ethnic group, although the minority Tutsi tribe has traditionally held power. Melchior Ndadaye, a Hutu, was Burundi's first democratically elected president. His assassination by Tutsi army officers in late October 1993 triggered violence between the two tribes. The conflict spilled into Rwanda and led to one of the worst civil genocides in history. It took place under the indifferent eyes of the French and Belgian soldiers who were in Rwanda at the time. The genocide forced nearly a million Hutus into exile.

How many children in Rwanda, and in other countries in crisis, have lost their lives or been driven into exile? At the refugee camps, they can get medical treatment from humanitarian aid groups. The care allows some of them to survive. But if they don't receive an education, they will not be able to create a better world. In my view, helping to provide them with an education is the world's responsibility to them.

RWANDA | *1994*

RWANDA | *1996*

Alfonsine told me her story: "I named my son Placide in memory of the love we shared, his father and I. I was 17 when I met him. It was before the events of 1994, before this land was covered with the blood of hatred. He was a Hutu. I am a Tutsi. After the Hutu extremists started killing Tutsis, and the Tutsis retaliated by killing Hutus, I decided to leave with him, and we fled with the Hutus. I walked for days and nights, going toward an unknown future. The Hutus rejected me, but I was happy to be with him. Our child was born. Not long after, his father disappeared. I did not belong with the Hutu refugees any longer; I had lost my protector. I took Placide in my arms and returned home. But in my native village, my people reject us, as if they wanted to erase the love his father and I had, since it's now forbidden for a Tutsi and a Hutu to be together. My brother wants to deny my past and steal my history from me in order to save his honor. He tells people that the Hutus took me by force, raping me and leaving me pregnant. But it was nothing like that. Only my grandfather, who has become withdrawn and silent because of the horrors that have happened in our country, loves us and supports us unconditionally."

The old man had been listening to his grand-daughter's story. He took his head in his hands. Only the pearls of despair in his eyes betrayed his emotion.

DEMOCRATIC REPUBLIC OF THE CONGO | *1995*

Portraits of the lost children. From where we stood, the other riverbank looked like paradise. The setting of the sun over the lush vegetation of Rwanda inspired in us a mood of contemplative serenity. On the lake, boats headed slowly toward us, leaving Rwanda behind. But when the men and women jumped out of their makeshift boats, their faces, distorted by fatigue and terror, revealed an entirely different truth: Hell, not heaven, was on the other riverbank. + When the carnage began between the Hutus and the Tutsis, the media was silent—a silence that is eloquent for what it says about the media. The battleground between the two tribes was the lake of Cyohoha on the border between Rwanda and Burundi. People on both sides of the lake had fled there as they tried to escape death. + The ethnic warfare had left many children on their own. Some were orphans, and others had become lost after being separated from their parents in the chaos of the war. The children roamed alone or in small groups. Looking for a little food to survive, they were everywhere, on the roads, in the fields, at people's front doors, and in the cities, which were still wildly dangerous. The children had seen horror, and some of them had been subjected to it, bearing the indelible marks of it on their bodies and minds. They courageously walked for miles, going wherever the road took them. They slept whenever fatigue forced them to stop. For these children, there was no playing anymore; there was only endless wandering in search of food. Several of the children had gone insane. Some acted bravely indifferent. Others, the luckiest, found shelter with some compassionate good soul. A few months later, millions of Hutus, fearing reprisals, fled Rwanda in panic. More than 20,000 children became separated from their parents during the upheaval. + UNICEF and the Red Cross launched a photo project to reunite these "unaccompanied children," as they became known, with their families. The plan for the project was simple: Take a picture of each child, gather whatever identifying information was available, then post the photos and the accompanying ID data in every refugee camp. But the sense of urgency did not last. As often happens, once the media left to cover other horrors, the world lost interest, forgetting about the Rwandan refugee crisis. A million people, though, lived in the refugee camps—huge, precarious settlements made of plastic tents. A human disaster had happened here, but the mobilization efforts and the financial aid monies had already gone elsewhere. Six months after the mass exodus, I returned to the refugee camps by the banks of Lake Kiwu. I learned that the unaccompanied children had been left to their sorry plight. The photo project had been suspended. Still alone, wounded in spirit, the children had been grouped together in special centers set aside for them at the camps. As time had passed, they were growing and changing, which might make them harder to recognize. There was, I thought, an urgent need to resume the project. In addition to working on my story assignment, I began to teach some of the refugees how to take photographs. I called people I knew and asked them to donate film and cameras—such a small thing to give compared with the value of a life. The photo project resumed. + We set up a photo exhibit in one of the refugee tents. The people who entered the tent seemed fascinated by the thousands of staring faces. Examining each photo slowly and carefully, they looked at every row of pictures, from top to bottom, and from left to right. For the family members who were looking for a child, each face represented a hope, a disappointment as well. + I remember the heartrending case of a grandmother who had lost her whole family, except for one of the baby twins born to her daughter, who had died during the exodus. A few months later, she came to visit the tent housing the photo exhibit, hoping to find the other twin. Since a few months had passed, the baby had changed. But she pointed her finger at a face on the wall, left to go to her tent, and came back with a baby sweater. It was the same as the one worn by the baby in the picture. Before the ethnic strife, she had knitted each of her twin grandchildren a sweater. That moment, when she identified and found the other twin, was the most moving experience of my life. + The photo project helped reunite more than 3,000 families. If our efforts helped to make just one child happy, just one family happy, then it was worth it. Photography had served a cause in a concrete way!

DEMOCRATIC REPUBLIC OF THE CONGO | *1995, mothers looking for their lost children*

DEMOCRATIC REPUBLIC OF THE CONGO | *1995*

DEMOCRATIC REPUBLIC OF THE CONGO | *1995*

In the Kashusha camp, some of the "unaccompanied children" crowded around Paul and Simon, who were leaving to be with their grandmother. Paul and Simon were their playmates and part of the little family they had formed in the camp, where they had gone after being separated from their parents. The other children's faces were sad. Even more troubling to see were the children whose faces looked blank and lacked expression. After a few months of waiting and loneliness, Paul and Simon were delighted not to be "unaccompanied" any longer. As for the other children, they would continue to endure the pain of separation and the bitterness of abandonment, their hope of a reunion with their families diminishing day by day.

In the Mudaka camp, it was a day of celebration for Séraphine, a dignified, elderly woman. She was hugging her two grandsons, holding tightly to the two boys who were all that she had left in the world. She had been searching for them for a year, finding them again through the photo exhibit of children who had become lost during the ethnic conflicts. Séraphine spotted their pictures among the portraits.

The dunes of oblivion. The desert stretched before us, dune after dune, without even the slightest shadow of a mirage. The old man pointed his finger at the infinity of sand and murmured, "Here is the desert of Taklimakan. Its name sounds hard and frightening, and makes people shiver when they first hear it: 'Go in and you won't come out.'"

During the era of the Silk Road trade, how many caravans passed near this natural barrier while carrying treasures from the East to the West, and from the West to the East? The two main routes of the Silk Road went around the desert, bypassing it and meeting up in the city of Kashgar. Taklimakan is part of a vast territory known as the Xinjiang Uygur Autonomous Region. For centuries, this area, whose Chinese name, Xinjiang, means "new frontier," was called East Turkestan. Many invaders, traders, travelers, and dreamers have trod its soil. In the 18th century, the Chinese government imposed its authority on the Turkic tribes who lived here, such as the Uygurs, the Kyrgyz, the Uzbeks, and the Kazakhs, as well as on the Persian-speaking Tajiks. In 1884, China annexed East Turkestan and made it a province. The Chinese set up a political structure similar to the one they have established in Tibet: Beijing repressed every vague stirring for independence, enforcing its control by encouraging the Han, the largest ethnic group in China, to migrate to the province and colonize it. The Uygurs, the province's majority population, are subject to the same fate as the Tibetans. But unlike the Tibetans, who have the Dalai Lama to represent them, the Uygurs do not have a similarly renowned figure as their leader, so their daily fight for recognition and equality is ignored by the rest of the world.

CHINA | *1995*

Bortala lies in the northwestern part of East Turkestan, between the rugged Tian Shan range and the desert. A soulless place, the town is like a large gray barracks. But it is in a strategic location and was built by the Chinese in order to establish their control over the Uygur population and the local oil reserves. Oil wells are strewn over the desert, their angular forms breaking up the tranquillity of the vast stretch of sand. Summers here are scorching; winters, harsh. Centuries ago, Marco Polo traveled across these desert sands. He told of seeing springs from which gushed a thick, black oil. This substance, he thought, had medicinal properties and could also ensure that barrels would stay watertight.

The sources of oil he spotted still exist. The black oil now bears the name petroleum, and the soil of the Silk Road and the deserts of East Turkestan, today known as Xinjiang Uygur, are said to be overflowing with it.

In 1955, oil was discovered near the city of Karamay, whose name is made up of the words for "black" and "oil" in Uygur, a Turkic language. By the end of 1955, the area was the site for the region's first oil drilling operation and first oil refinery plant. The local oil industry has since boomed: 25,000 holes have been drilled in the area to search for oil, 2,150 oil wells now operate in the Karamay, and two more refineries have opened. A fourth refinery is located farther south, in Urumqi, the capital of the province.

The rich supply of crude oil is one of the reasons why the Chinese government holds sway over East Turkestan, as it does over Tibet. As for the Kazakhs, the Uygurs, the Kyrgyz, and the other local populations, they are on the sidelines, watching as the pipelines go through their land and carry off the oil, the profits from which will accrue to the government in Beijing.

In childhood, the experience of reading has an incomparable flavor. For a young reader, words and stories about faraway places are not just a simple invitation to travel, but a call to a horizon freighted with mysteries. Reading about such enthralling locations often then inspires a child to make a secret pact: to go visit these places someday, so that these words, these places are no longer merely black ink on a white page, but become a lived and felt reality. Some texts seem to evoke a bygone era, conjuring up a world that now belongs to history. I am thinking, for instance, of the writings of ancient travelers or of the poems of Sa'adi. Likewise, as I discovered East Turkestan, I had the impression of being immersed in the books from my childhood and of traveling through time.

Qarokul Lake is on the road that separates the city of Kashgar from the tall peaks of the Pamir mountain range. Qarokul means "black lake" in Uygur. A caravan of travelers had stopped for a moment near the icy lake. Glaciers towered nearby. The Pamirs include a hundred glaciers. Muztagata, parallel to the edge of the Pamirs and known as the "father of ice mountains," reaches 24,757 feet.

CHINA | *1995*

CHINA | *1995*

The historical memory of my people seems to have crossed the centuries, for I carry within me a sense of the time when the Persian Empire confronted the Chinese Empire, as if this long-ago conflict were part of my personal recollections. In 1987, China was just beginning to open itself to the outside world. I had the chance to cover the first race of single-engine propeller planes between Paris and Beijing. During this extraordinary event, our tribe of small planes was able to fly over the Chinese countryside before finally landing at the airport in Beijing. I was then to see more of China in the decade that followed. While on assignment for two articles for *National Geographic,* I went to East Turkestan in 1995, and to the banks of the Amur River in 1999. I also taught several photojournalism classes at the University of Beijing. Highly motivated, the students there were eager to learn quickly so that they could achieve success even faster. Over the course of

these experiences, a veil was lifted, and I came to have a better understanding of the Chinese, who, for me, seemed a mysterious people. They prompted a questioning attitude on my part, but also admiration. I have always been drawn by the incredible drive to succeed that emanates from the Chinese and by the unmatched level of organization of their society. Above all, I was impressed by their capacity for work and their tremendous determination, which surpassed what I had seen in any other country. Nonetheless, I did not fully understand the extent of their strength and perseverance until one day in February 1999, when I was in a village on the Amur River at the time of the Chinese New Year. The sky was blue, and it was minus 40 degrees. The villagers were preparing for the New Year festivities and the traditional dragon parade. I saw the dragon in front of a crowd of onlookers. It had a disproportionately large head and a huge body. Its long tail moved with grace. But you could not see the people who were making the dragon dance. All that was visible was their feet. The dancers were

bending over and crouching inside the body of the beast, moving in total harmony. The choreography was perfect, expertly capturing the beauty and power of the dragon. Watching this performance is how I came to grasp, visually, the might of the Chinese. Their system of mass education, which subordinates individuality in favor of common interests, is the key to their supremacy. "Together, we will make the dragon supreme," the dancers seemed to be saying with their bodies, as they carried the dragon in tight coordination. China is on a march to overtake the West's industrial and economic power. Considering the galloping population growth in China, I predict the country will embark on another march, a massive, organized campaign to dominate Central Asia and the Caucasus right up to the Urals, leaving only the mountain range as its border with the empire on the other side, Russia.

CHINA | *1995, the Chinese Army*

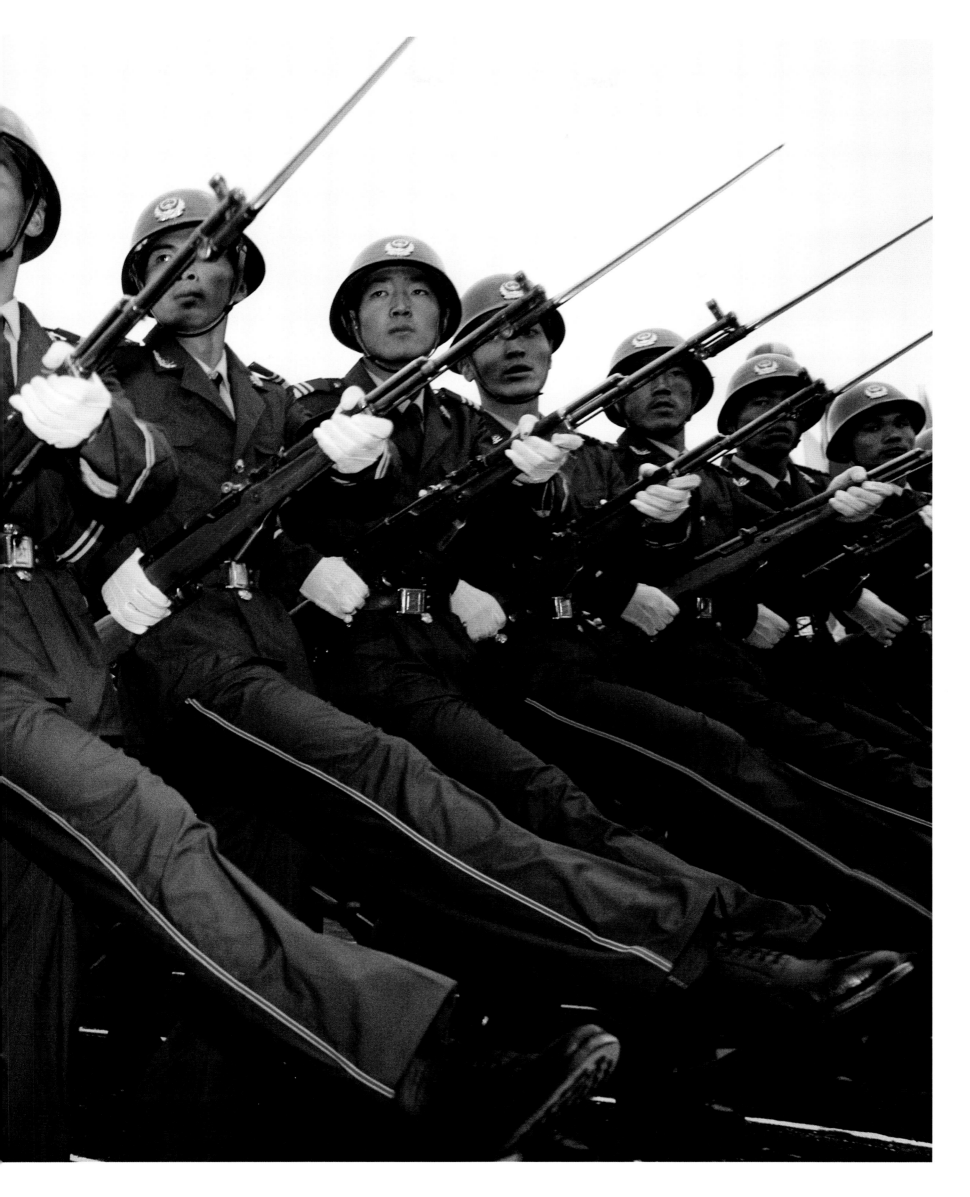

In the 18th century, the Manchu emperors, who ruled China at the time, wanted to secure their control over Central Asia, including East Turkestan—now the province of Xinjiang Uygur—and extend it to Lake Balkhash, at the doorstep of the Russian Empire. To colonize this area, they organized a migration from their homeland of Manchuria. The peoples of Manchuria, who were not ethnically Chinese, were known for their ferocity while fighting on horseback and for their unequaled skill as archers. The Manchus conscripted men from local tribes, such as the Xibe, to serve as military garrisons on the western frontier, where they resettled with their families. Their proficiency as warriors made them a critical asset in crushing any resistance from the native Turkic nomadic tribes. In the centuries that followed, the Chinese regained power and eventually overthrew their Manchu overlords. The tradition of archery remains strong among the Xibe people, so much so that they have won several medals for China in international competitions.

A group of Xibe schoolgirls waits patiently to go on stage and perform a song as part of the 40th anniversary of China's annexation of Xinjiang Uygur in 1955. The descendants of the Xibe still live in the area, forming a small percentage of the population.

CHINA | *1995*

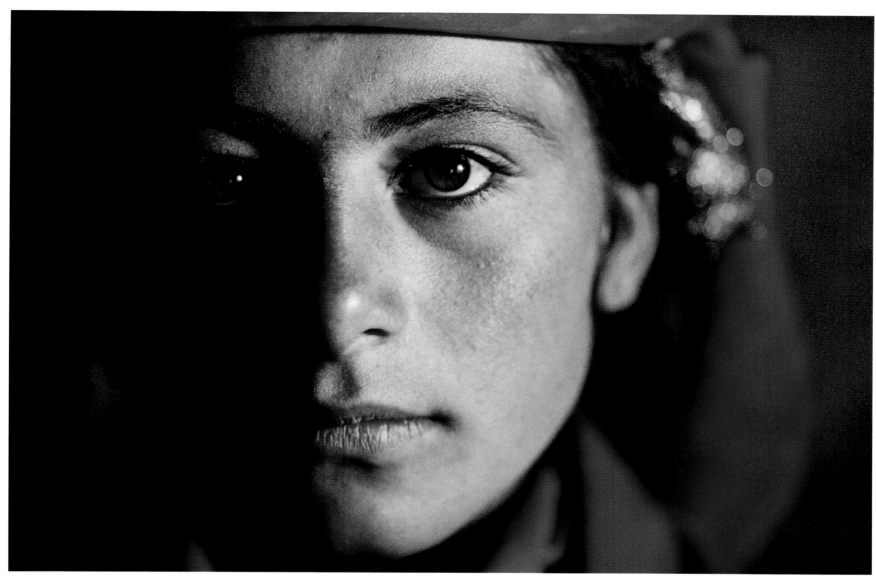

CHINA | *1995*

Only the rhythmical clopping of his horse's hooves resonated in the plain of the Altay Mountains. The immense plain, in East Turkestan, was plunged in darkness. In the blackness of the night, he could not make out anything. But he would be able to hear, from the sound of her footsteps, from where she would come and take him by surprise. As he passed the yurts in the camp, he listened to the people's peaceful breathing, a reassuring sign that they were deeply asleep.

He waited for her. Suddenly, a cloud unveiled the full moon, the only witness to their rendezvous.

She was there.

CHINA | *1995*

CHINA | *1999*

All over the world, millions of men and women face economic exile. In China, a new "Long March," this time based on the values of capitalism, is heading in the opposite direction from the economic principles that were the foundation for Mao's ideology. Since the start of the market economy in China, an estimated 150 million peasants have fled the countryside, cramming into shantytowns on the outskirts of major cities. They are trying to find work to make up for the loss of the subsidies once granted by the government. They are forced to accept any type of job, no matter how terrible the conditions or how little the pay, often working for multinational companies that make products sold cheaply in the West.

In order to establish its authority over Xinjiang Uygur, the Chinese government decided to split the vast region into smaller units, such as prefectures and counties. In 1995, I traveled to the area while covering a story for *National Geographic* magazine. The year 1995 marked the 40th anniversary of the annexation of the region by the Chinese, and I witnessed a considerable difference of opinion about this event. The native inhabitants, who are mostly Turkic, perceived the annexation as an invasion, while the Chinese authorities saw it as the declaration of independence for the region—everything, it seems, depends on one's point of view.

Perched at an altitude of 13,000 feet, Mazar is an immense plateau in the Pamir mountain range. Carefully placed, as if they were special tablecloths laid out for a feast, carpets add little dashes of color to the wide, green plain. They served as seating for spectators during a game of buzkashi, a form of polo. From ancient Persia to East Turkestan, from the Caspian Sea to Central Asia, carpets have long been both works of art and daily household objects in the countries of this region. Dressing up the interior of a house or yurt, they are like paintings with skillfully worked designs woven of silk or wool thread. They insulate walls and are spread over the floors, where people sit on them.

Our house in Tabriz, where I grew up, had several rugs made in our town. Their patterns, compositions created out of lines and colors, marked the visual field of my childhood. I used to amuse myself by following their curves with my finger. No doubt they trained my eye.

His rifle is heavy and cumbersome, but it reassures him. The weapon has become his accomplice, as well as his guardian. He feels strong when he holds it. With it, he finds it easy to order drivers to pull over, and then threaten to do a routine check of their cars. Thanks to his rifle, he feels protected and invincible. It is his confidant, and his guarantee that he will be able to carry out his revenge someday. He puts on a Rambo belt. His khaki uniform, covered with dust, is much too big for his frail, childish body. He has the face of an angel. But his expression is harsh and sad.

Chang is 12 years old. He lives by the side of a road in Cambodia. Although he is a street child, he serves as a soldier in an armed squadron. As part of his duties, he stops people to perform searches or to question them. Sometimes he kills, doing it without any qualms.

"I was ten," he told me. "My father was a soldier, and I was traveling with him and his unit, leading an army life along with him. But at that time I wasn't a soldier yet. We were near the front, close to the zone controlled by the Khmer Rouge. One day, as I was walking behind him, I heard a very loud noise. The blast blew the ground into a thousand bits. When the smoke cleared, I saw my father. I sat down next to his body, which was torn up and stained from the earth. I stayed there for a very long time. I didn't want to leave his side, so I just sat beside him without moving. I promised him I would avenge him. I became a soldier after that."

I took Chang to an orphanage for street children. I gave him a harmonica to replace the rifle he'd had to leave behind. Within hours, he was already playing melodies on it. Chang took a new lease on life, a life that had seemed buried forever. He was laughing. But two days later, Chang was like a bird in a cage. His spirit had shriveled up. He withdrew, finding sanctuary in silence. Nothing and nobody could stop the devastating madness of his self-imprisonment.

Chang ran away from the orphanage, telling his roommates that he had to avenge his father. He took only the harmonica with him.

CAMBODIA | *1996*

This train links Battambang to the city of Poipet, near the Thai border. Each day, Cambodian peasants would jump on it to go sell their meager harvest in Thailand, which was a wealthier country than Cambodia. At that time, Cambodia was still in the dark era of Pol Pot. The train ran through the zone controlled by his men, the dreaded Khmer Rouge, and was the target of bloody attacks. Even more insidiously, the Khmer Rouge placed mines on the rails, and they would explode when the train passed. To protect the driver, the Cambodian government put armor around the engine and had the idea of having a flatcar precede the engine, so the wagon would blow up first if the tracks were mined. People could ride on the flatcar for free. The poorest Cambodians—women, men, and children—used to rush onto it at every trip. In the intoxicating wind of the train ride, they went to the Thai border to earn what they could in order to survive. They also went to their possible deaths.

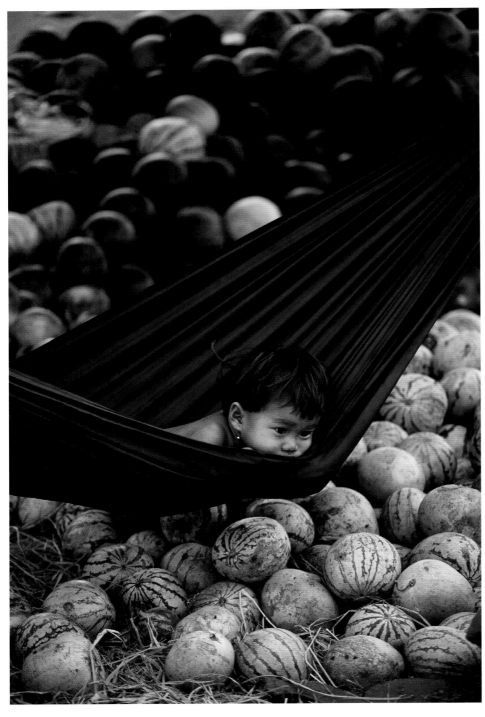

CAMBODIA | *1996*

The land had been left to lie fallow for several long years, the terrible years of the Pol Pot regime. The wide field looked suitable for farming, with earth that could be plowed and sowed. But it lay abandoned, and a sign indicated that no trespassing was allowed because of antipersonnel mines. Some argue that planting mines helps protect an army's positions. But those who have experienced war know that long after the peace treaties have been signed and the guns have gone silent, the "weapon of the coward" continues to carry on its work, for years.

Craftily placed, a mine often hides where you don't expect it, nestled in the gullies of a field, or concealed under some lush vegetation. Mines cause the highest number of civilian casualties, killing or maiming civilians throughout the world, from

Afghanistan to Sarajevo, from Angola to El Salvador, from Kurdistan to Cambodia. Whereas antipersonnel mines bring tragedy to civilians, they bring fortunes to the companies that make them. It costs a dollar to manufacture a mine, but a hundred dollars to clear it. Often, the companies that manufacture mines handle their clearance, too!

In Cambodia, as in every country where I had met people wounded by mines, the victims were usually adults. I was surprised by this, as I knew that children had many ways to set off a mine, such as chasing into a field after an animal, playing hide-and-seek on the street while on the way to school, or picking up small, colorful plastic "toys"—mines that looked like playthings. (The Russians were masters at using mines in the shape of toys, butterflies, and pens, hiding them around Afghan villages.) The injury rate from mines had to be high among children, yet I saw very few children who had been mutilated by them. Later,

a nurse told me the sad reason. Children, in fact, were the main victims of mines, but they often died from their injuries. Their short stature gave them little chance of surviving. Since their bodies were closer to the ground, their vital organs were often struck by the blast of a mine, making the weapon deadlier for them than for an adult.

While I was in Cambodia, I met this man, who had lost his leg on a mine. He and his family had become separated because of the warfare in the country. In the meantime, his wife and children had lost their home and their land. They had been searching for one another for several months. Then he learned that his small family had settled in a hammock strung between two poles, setting up camp right on the sidewalk. This was the day of their reunion.

Over the years, people had built huts around Phnom Penh's landfill, creating a shantytown whose economy was based on trash. Entire families lived there. Toddlers took their first steps and played their first games in its dismal environment, which had an unbearable, persistent smell. As soon as the children became old enough to carry a load of trash, they were put to work. They waited for the garbage trucks to return from the city. When the trucks dumped the refuse, the children, each equipped with a big bag, rushed to salvage whatever they could sell for recycling. The money helped their families survive. Urban waste for the residents of Phnom Penh—the trash—for these families represented a means of existence. The children frequently suffered from skin diseases and eye infections. What a strange vision of the world this scene presented—the children scavenged the mountain of waste, going through it to find consumer products that arrived from a city far away, from a life that was not theirs, and that probably never would be theirs.

Black gold's blood. For hours on end, babushkas stand on street corners hoping for a handout. Even after waiting for hours, these old Russian grandmothers may not get any money. In their younger days, they fervently sang the praises of Communism. In Russia, how many people are there who, in their youth, were enthusiastically committed to the Soviet cause and tried to impose its ideals on faraway countries—from the Chinese border to the mountains of Tajikistan, from the Central Asian steppes to the banks of the Caspian Sea, from the Baltic coast to the ice deserts of Siberia?

After the collapse of the U.S.S.R., the former Soviet provinces in those regions became independent. The newly emerging countries, as well as Russia, have shifted to a market economy, developing a capitalism with few social safeguards to protect their people.

The Amur River borders Russia and China. I saw this man on the Russian side, in the town of Khabarovsk. A poor pensioner living on the streets, he staggered and looked lost. His clothes had become rags. When I asked his name, he began to weep. He said no one had asked his name in ten years. His name was Gennady Vaslyevich. Through his half-open shirt, I glimpsed the portraits of Marx, Engels, Lenin, and Stalin, symbols of a bygone ideology. He had the tattoo done while he was a soldier. He did not know what I had learned: In Siberia, prisoners in the gulags had those four faces tattooed on their chests to avoid the firing squad. What Soviet soldier would have dared shoot at his heroes?

After the fall of socialism, and with the subsequent revival of the right to express religious feeling, Vaslyevich had added a new icon to protect him, a cross.

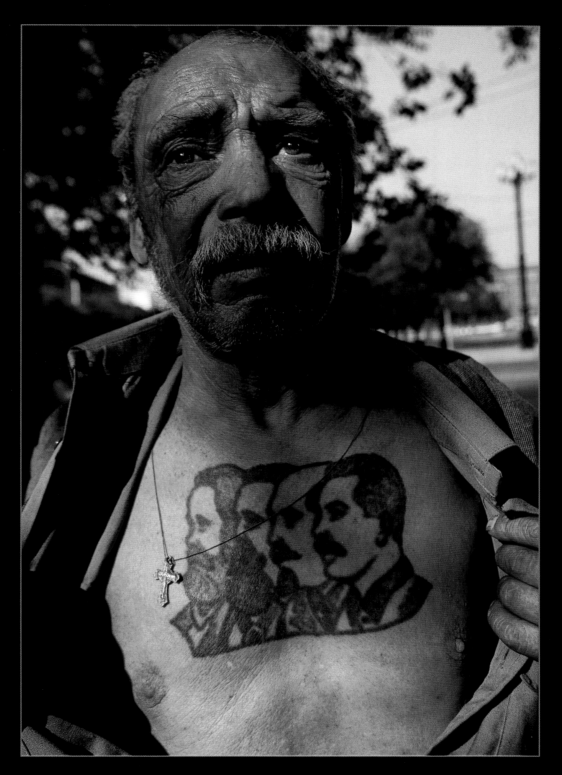

RUSSIA | *1999*

A former Soviet military base, Nargin Island was once classified as a "secret defense" zone, where the Red Army could prepare for a possible attack against the Azerbaijani capital of Baku and its oil fields. Now there is nothing but silence and the ruins of a fallen empire. Soviet warships offer up to the Caspian Sea their rusty flanks, vanquished by time and decay.

KAZAKHSTAN | *1997*

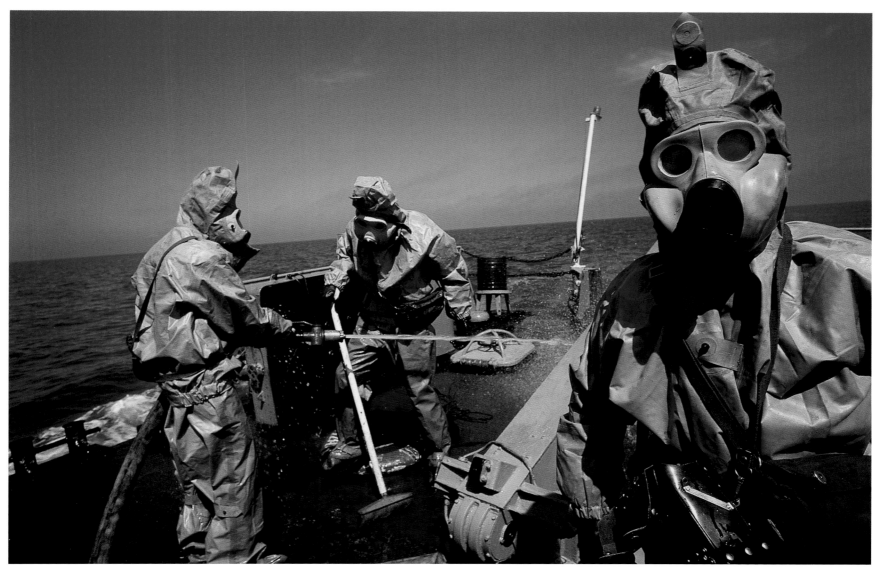

AZERBAIJAN | *1997*

In the early 1990s, the Kremlin lost control of its political satellites. After its former provinces in Central Asia and the Caucasus became republics, the newly established countries that surround the Caspian Sea became the focus of a major political and economic contest between the United States and Russia, and, to a lesser extent, Europe. For strategic reasons, all three were eager to exploit the rich resources of the Caucasus and Central Asia, whose subsoil overflows with gas and oil, and were bidding for the right to have access to them.

A multinational oil company won a large share of the market in the Caspian Sea. The process of extracting the oil produces a by-product, red liquid sulfur. When it comes into contact with air, it solidifies and turns yellow.

The stain of the red liquid looks like blood. Oil and blood are often linked: In countries rich with oil, blood is often spilled.

Have you ever tried to undertake the strange journey of transposing yourself into somebody else's mind, body, and life?

Imagine. You are standing in a vast white salt flat. Temperatures vary between 4°F and 104°F. The wind blows wildly all year long, lifting the salt all around you, each grain a perverse needle that pokes even the tiniest area of your exposed skin. Sometimes you sink up to your knees in the marshy salt, working a 12-hour day that never seems to end. If, by misfortune, an especially sharp crystal pricks your skin, your suffering becomes unbearable as the salt bites into your flesh. Beside you, hundreds of other men are also working. Like you, they are bent over, their feet held prisoner in the white wasteland.

His name was Farhad. He heard the click of my shutter. Slowly, he raised his head and gave me a bitter smile. "I wish I had a picture of myself from a few years ago so you could compare it to what I look like now."

He took a break for a few minutes and told me his story: "I was a teacher for 18 years, then became a principal at a high school. I lived with my wife, my five children, and my parents near Karabak. We had a good life until the war with Armenia. One day, we heard that the Armenian military was coming closer to our area. We learned that towns were falling one after the other into the hands of the enemy and that houses were being burned down and people were being slaughtered. The luckiest ones had to flee. We hoped we'd be spared, but then some Armenian soldiers came to our door. Now, my family and I are refugees and live in a slum outside Baku. I work all day at this salt flat so I can feed my children. Working here is hard. But the hardest part of all for me is that I can't provide them with an education. They don't go to school anymore, and my day is so long that I can't teach them myself. I don't live near these salt marshes, and when I finally get back home at night, they are already asleep."

AZERBAIJAN | *1997*

KAZAKHSTAN | *1997*

The sound of childish laughter, amid this desolate forest of rusty oil pumps, surprised me. I was trying to make my way though the oil field despite the garbage that had accumulated after the oil wells had stopped running. Junked cars, trash cans, and plastic items, some light enough to twirl around in the wind, littered the tall, dry grass. Some goats fed on the grass. Their shepherd, an old, hunched-over man, herded them in silence. I was looking for a good shot to take. A few oil pumps still operated, and their creaking made me imagine how this oil field must have once looked, with the dance of all of these steel pumps moving in a regular rhythm. In the late 19th century, Azerbaijan had a booming oil industry. The black gold in the area's soil created fortunes, often enriching families that were already among the richest in the world. Then the long Soviet years paralyzed local oil production.

I found the source of the laughter. Two boys, brothers named Tabriz and Jeyhun, were playing near a small, isolated cabin.

I met their father, Mahmud. His face looked solemn and overwhelmed by sadness. In a somber voice, he told me about his past, plunging into the story of his life as if he wanted to unburden himself. "My house was beautiful and welcoming. We lived in a village up north. We were happy there. When life is simple and peaceful, it seems as if it will always stay that way, right? But when there's a war, we civilians become the victims of issues that are beyond our control or our understanding. We had to flee after some Armenian soldiers destroyed my house. Eventually I found this abandoned cabin. But, here, we are prey to the wind and are surrounded by the gloominess of this old oil field. Here, we don't live, we survive."

Azerbaijan had many refugees like Mahmud, who had fled to the area around the capital of Baku from another province of Azerbaijan due to a war with Armenian separatists in the early 1990s. Many of the refugees once had professional careers, working as engineers, technicians, or teachers. The Russians had stirred up the conflict between the Azerbaijanis and the Armenians in order to create instability in the region, which served the Russians' strategic interests. Armenian soldiers invaded the Azeri towns and countryside, forcing hundreds of thousands of people to flee to Baku, leaving so fast they had no time to take their belongings. They brought nothing along but the bitterness of their memories: the remembered images of their houses burning down, their goods being pillaged, their loved ones dying, being killed. Since then, the refugees have been trying to rebuild their peace of mind, perhaps an improbable hope as they struggle just to find their daily bread. In Azerbaijan, the war displaced about a million people, out of a total population of seven million.

I can still hear the two boys' childish laughter, a touch of irony as I remember all of the lives shattered by war and injustice the world over.

TURKMENISTAN | *1997, dance of angels on the Cheleken Peninsula*

Preceding pages and opposite: A wanderer like Ulysses or Sinbad, I circled the Caspian Sea for nine months, passing through Azerbaijan, Kazakhstan, and Russia to arrive at Turkmenistan, my final destination. In each place, I made an effort to understand the country, its economy, its people and their history, their traditions, their daily lives, their joys, their sufferings, and their expectations.

Turkmenistan is known for its famous breed of horses, the Akhal Teke, and for its folklore. The country is rich in gas, most of it found in the Cheleken Peninsula. I had reached the small town of Cheleken. At the edge of town, a wide, arid plain yielded to the blue vastness of the Caspian Sea. Two graceful, free-spirited "angels" appeared in front of me. The girls were dancing in the breeze and playing with the puffs of wind. They belonged to a folk company that performed great scenes from Turkmeni history, and were rehearsing with their troupe. At the moment, they personified the angels in a traditional dance about evil spirits. Curious, I asked what the evil spirits were. The troupe leader pointed to the black smoke in the distance. "Look at that smoke," he said. "It's constantly covering over our beautiful Eden. That is our bad spirit. The oil is being burned to make car tires. Some are growing rich from it, but it is ruining our lungs."

SIBERIA | *1999*

AZERBAIJAN | *1997*

Opposite: The Old Believers practice a traditional form of Russian Orthodox Christianity. To escape religious persecution, they settled in isolated villages in Siberia. They remain secluded in their own communities. Like the Amish, they work the land and live the old way, cut off from the world and rejecting all modern comforts. Strangers have a difficult time entering into their midst. But I was able to join them on the occasion of a religious celebration, when I captured this intimate family moment.

Above: The town of Astara, divided between Iran and Russia for decades, was a special town for me during my childhood in Iran. We would go there to bathe in the Caspian Sea. The sand felt warm under my feet. The air was heavy with sea spray, and I enjoyed standing at the shore, watching the waves come up to my toes, then ebb back. In 1997, during my long photo assignment on the Caspian Sea, I went to visit the other Astara, the Azerbaijani Astara, the one I had imagined as a child, on the other side of the border. I went as close as I could to the city's border with Iran, to breathe the air of my forbidden country. Geese crossed the border line, guarded by customs officers; I did not.

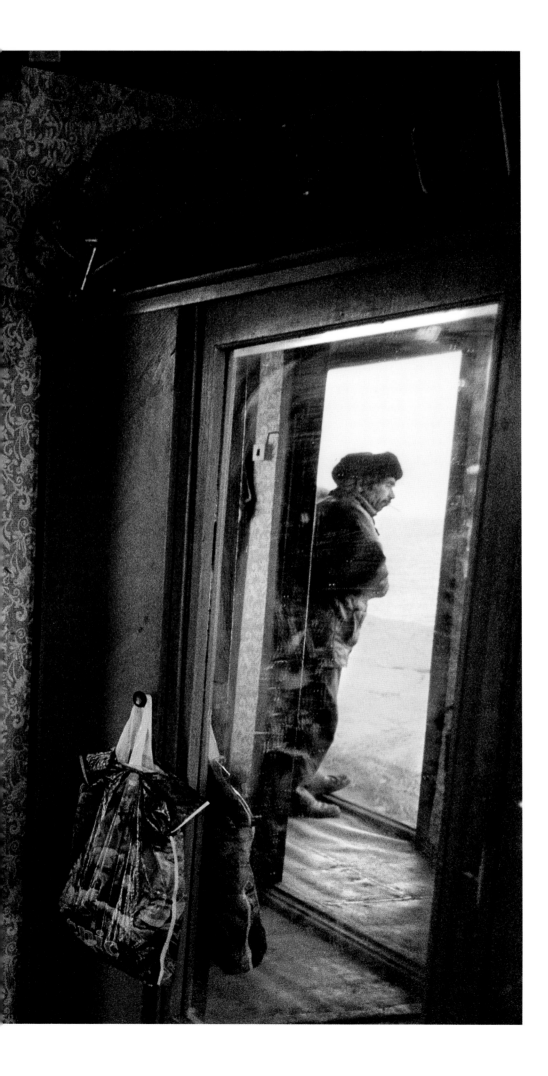

After the collapse of the Russian Empire, social disparities became more evident among the people in the Caspian region. This financial precariousness affected even those who, up to then, had been spared destitution. Only a small, privileged minority profited from the explosion of wealth tied to the oil trade. The working class entered an era of suffering and extreme poverty, some turning to illegal activities, such as poaching, to make ends meet. A former phone company technician, this man had just finished spending a long night poaching sturgeon. He had lost his job after the dissolution of the Soviet Union. Sturgeon, the source for caviar, are an endangered species. Most of the world's caviar comes from sturgeon from the Caspian Sea. But, living in its extremely polluted waters, they are threatened with imminent extinction.

RUSSIA | *1997*

A portrait hangs on my wall. It is drawn in pencil, or perhaps charcoal. My father's features are smooth; the years and suffering had not yet furrowed them. His mustache is small and brown. He proudly sports the headdress widely worn by men in the Caucasus. I never saw this youthful man—he already looked older when I was a child. The portrait is of him when he traveled in the Soviet Union during the 1940s.

Fifty years later, during my story assignment on the Caspian Sea, I was following in my father's footsteps, retracing his path.

I had reached the remote village of Nardalan. I was looking for a place to rest for a few hours, or perhaps a few days, to replenish myself in an atmosphere reminiscent of my childhood. The sun had just risen. The bustle of the day had not yet begun. I strolled along the deserted streets, immersed in daydreams. I encountered an old man, who looked proud but gentle, seeming both dignified and vulnerable. After exchanging a few words in Azeri, he asked me, with emotion in his voice, "You're from the south?" When I answered yes, he broke into sobs. "I am from the south, too," he said. "I was a year old when my parents decided to visit relatives here. But then the border was shut down, and we couldn't leave. My childhood was marked by the grief my parents felt because they could never go back to their loved ones. They had left them for a few days that stretched into forever."

As I listened to him, buried memories resurfaced in my mind, scenes from my childhood in Tabriz. I thought I heard my mother's melancholy song of *Ayriliq*, which evoked the sorrow when Azerbaijan was arbitrarily divided in two. My father gave me the historical explanation for the separation, which had torn families apart, stranding family members on both sides of the Aras River.

This old man had grown up, and grown old, in that forced exile.

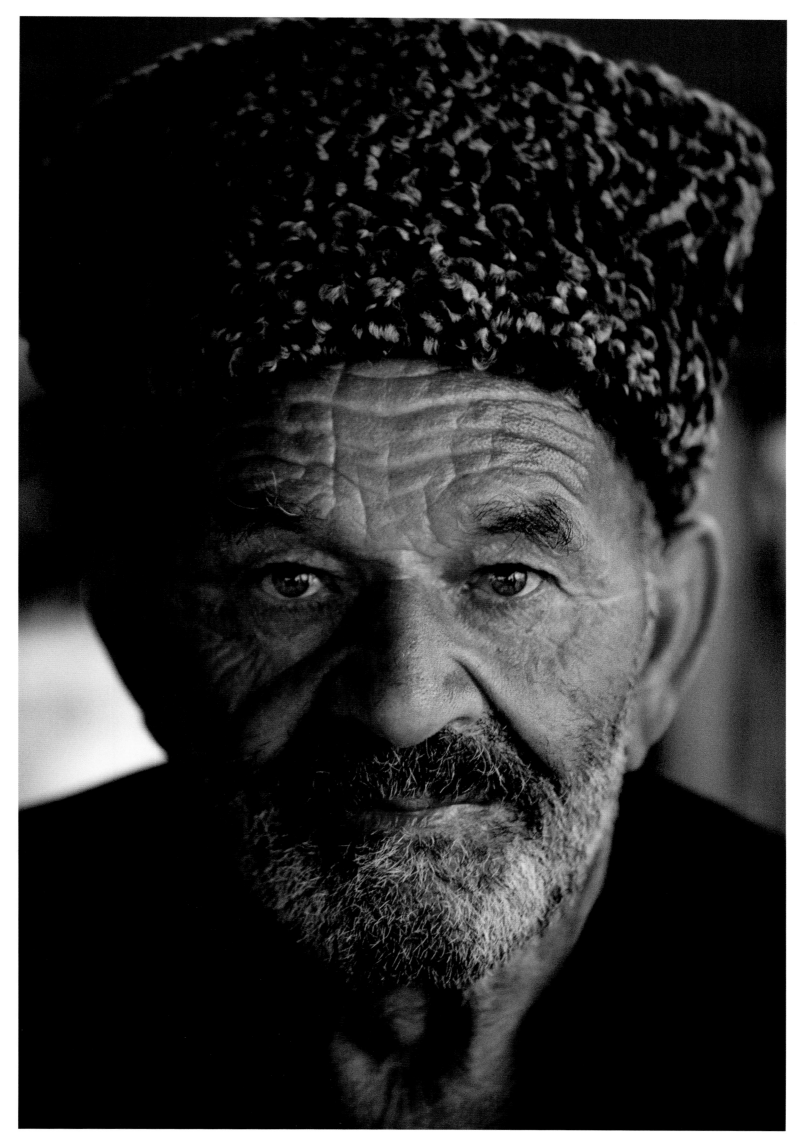

The earth shook for the first time at three in the morning, in the heat and torpor of summer. The temblor struck on August 17, 1999. Its epicenter was located on the shores of the Sea of Marmara, just on the outskirts of Istanbul. The quake ran along the notorious North Anatolian Fault. The tectonic plates that had caused the fault had triggered several earthquakes in Turkey over the course of its history. That night, the tectonic plates shifted again, jolting thousands of people while they slept. We had arrived in Turkey the day before for a family vacation. Although we were staying far from the epicenter, we, too, were awakened in the middle of the night, unaware of the tragedy that had just occurred. The next day, I started to cover the earthquake for *National Geographic,* and was plunged into the country's painful saga of deadly quakes over the centuries.

Many apartment houses had collapsed. The sight of these modern buildings, with floors pancaked on top of one another, evoked houses of cards. But this was no game. Under those cards lay thousands of dead men, women, and children. Government authorities had granted building licenses for the construction of major real estate projects along the seismically active fault line. Contractors had built entire apartment buildings without observing safety standards. Many of them had grown rich by building these residences, which had turned into true concrete caskets: The structures collapsed in just a few seconds, burying up to 40,000 people alive. In Ceyizlik, the mosque's minaret did not survive the wrath of the gods.

Who wouldn't want to swim among the columns of the Temple of Apollo of Hierapolis? The ancient holy city, which was ceded to the Romans in 133 B.C., stood above the Pamukkale hot springs in southwestern Turkey. The victim of destructive earthquakes, these ruins, engulfed in thermal waters, are all that is left of the splendor of the past. Warm and pleasant, the waters are like caresses on the skin of passing tourists.

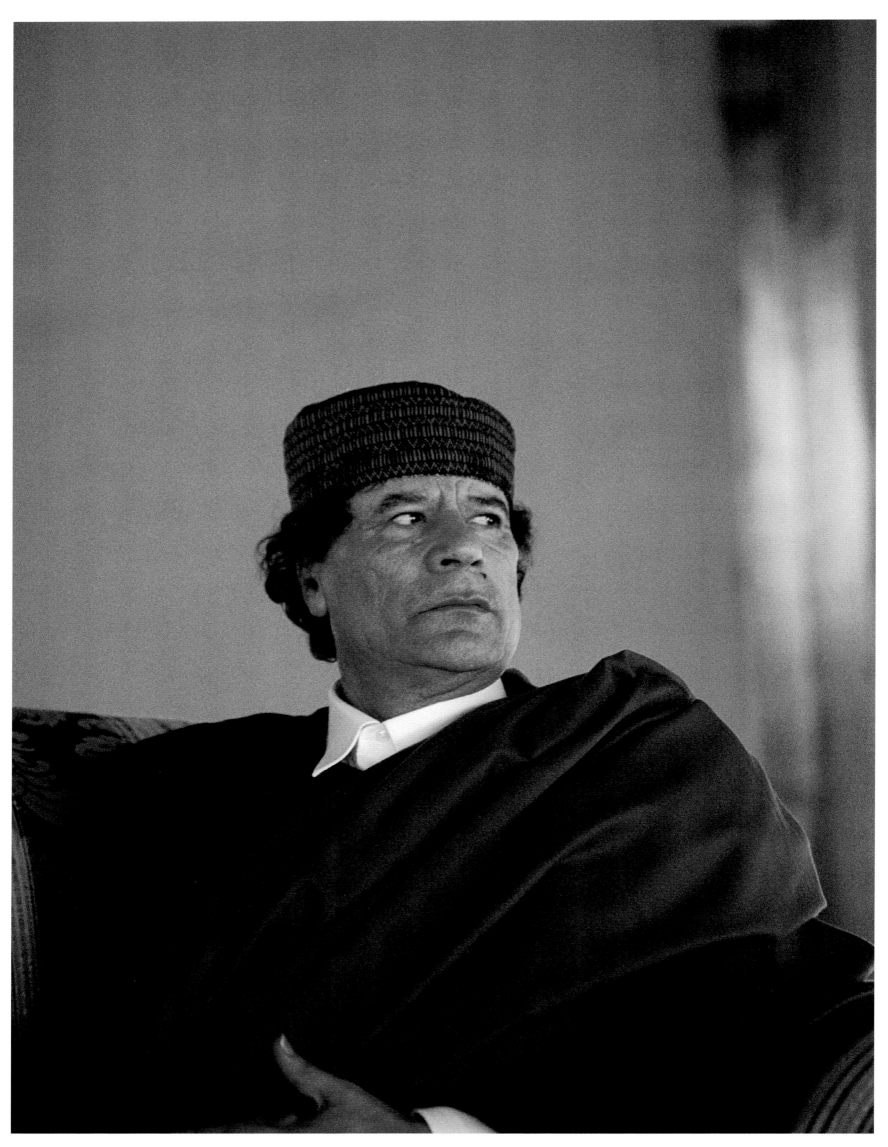

Desert dunes were his skyline. For light, he had the canopy of stars. Camels were his travel companions, and his silent escorts in the great stillness of the desert. This was his world as a child. It is said that Muammar Qaddafi, the son of Bedouin nomads, was a camel shepherd in the desert until he was ten. Then, taken in by a family, he began to go to school regularly, and his intelligence led to his becoming an army officer at a young age. Thus was born the legend of Qaddafi, who has ruled Libya for more than 30 years. Though he has brought his people economic and social well-being, as well as an exemplary educational system, he has not managed to open his country to basic freedoms, among them, the freedom of speech.

LIBYA | *2000*

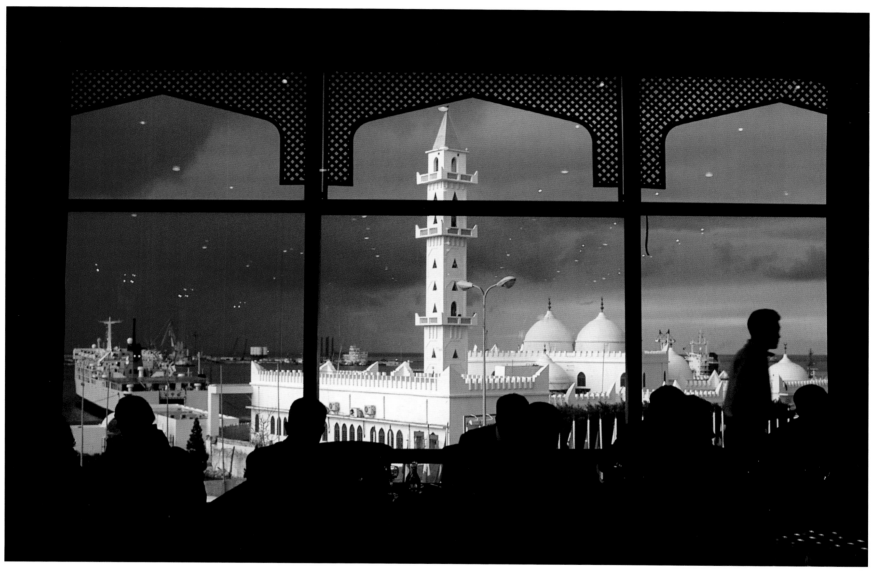

LIBYA | *2000*

Beautiful young women in uniform stand behind the colonel. Wisps of their long hair slip out from under their berets. For more than 30 years, Qaddafi's corps of bodyguards has been made up of military women. This scene may be surprising for a Muslim country. Since the time of the shah and the Iranian revolution, I have traveled in numerous Muslim countries that are hesitating between Western culture and a return to religious obscurantism. Libya has managed to accommodate a slow but steady march toward modernization: It permits, but controls, the nation's openness to Western culture, and it maintains a separation between religion and the state. It is a country of contrasts and coexisting customs, where women wearing pants pass by women who are completely covered by their traditional Bedouin dress, from which only an eye can be seen.

1980	IRAN
	ITALY
1981	FRANCE
1982	LEBANON
	LIBYA
	TURKEY
1983	AFGHANISTAN
	PAKISTAN
	ALGERIA
	INDIA
1984	LEBANON
	TUNISIA
	YEMEN
	GUINEA
1985	AFGHANISTAN
	JORDAN
1986	PAKISTAN
	PHILIPPINES
1987	CHINA
	SINGAPORE
	UNITED ARAB EMIRATES
	INDIA
	SOVIET UNION
	AZERBAIJAN
1988	ISRAEL
	PALESTINE
1989	SOMALIA
	SUDAN
1990	AFGHANISTAN
	UZBEKISTAN
	TAJIKISTAN
	AZERBAIJAN
	RUSSIA
1991	EGYPT
1992	RWANDA
1993	TURKEY
	CONGO
	ETHIOPIA
	KURDISTAN
	SOMALIA
1994	RWANDA GENOCIDE
	CHINA
1995	CHINA
	RWANDA
	BURUNDI
1996	CAMBODIA
	EGYPT
	ZAIRE
1997	AZERBAIJAN
	RUSSIA
	KAZAKHSTAN
	TURKMENISTAN
1998	AFGHANISTAN
	MOROCCO
	BANGLADESH
1999	RUSSIA
	CHINA
	KURDISTAN
	TURKEY
2000	**AFGHANISTAN**
	TAJIKISTAN
	ISRAEL
2000	EGYPT
	LIBYA
	SAUDI ARABIA
2001	SYRIA
	AFGHANISTAN
	TAJIKISTAN
2002	SAUDI ARABIA
	CHINA
2003	SAUDI ARABIA
2004	AFGHANISTAN
	INDIA
2005	EGYPT
	AFGHANISTAN
2006	PAKISTAN
	EGYPT
	MOROCCO
	SRI LANKA
2007	AFGHANISTAN
	AZERBAIJAN
	TURKMENISTAN
	JORDAN
2008	ISRAEL
	PALESTINE
	INDIA
	AFGHANISTAN

The last breath. Ten years had passed since the Russians had been forced to withdraw from Afghanistan. The defeat had made a crack in the power of the Soviet Union and led to the dismantling of the Berlin Wall. The huge oil and gas reserves of the Caspian Sea had thus been freed from the Kremlin's control. The new republics in the region signed contracts with countries in the West to exploit these resources. Only the route for the oil pipeline remained to be established. But then tensions mounted between Russia and the West, which was eager to take control of the former Communist interests. The war in Chechnya and the conflict stirred up by the Russians between Azerbaijan and Armenia blocked any attempt to lay the pipeline through those areas. The pipeline could not run through Iran, since, in the eyes of the West, the Islamic Republic was a bête noire. The only possible route was through Afghanistan. Civil war in Afghanistan, however, prevented that route from being an option. Oil companies did all they could to secure Afghanistan as a passage for the pipeline. Toward that goal, the CIA and the Pakistani secret service supported a group of Islamic theology students, the Taliban, to take over Afghanistan. They ruled the country by terror. The Western powers were slow to react. Only Ahmad Shah Massoud resisted. His stronghold was the Panjshir Valley. Many families found shelter there. Mustafa Gol's wife, eight months pregnant, had walked day and night to reach Massoud's camp. The face of her baby, born in the camp, has the pale, gray cast of death. He is suffering from cold and hunger.

AFGHANISTAN | 2000

Though he was on his own turf, Massoud had been forced to retreat as the Taliban, at that time supported by the United States and Pakistan, gained ground. I wanted to photograph Massoud to show the world a fairer image of Afghanistan, and of the cause he defended. Sebastian Junger and I went to Afghanistan to meet with him as part of a documentary for National Geographic television.

Not far from Tajikistan, the Kukcha River had become a natural border between the forces of the Taliban and the resistance led by Massoud. The plain of the river was a wide, exposed stretch of land surrounded by hills. The Taliban and Massoud's fighters had staked positions in these hills and were defending them fiercely, firing bullets and rocket artillery at one another across the plain. We had crossed the plain and had hiked up to one of the Taliban positions that had just been taken by Massoud's men. Hiding in the ocher-colored desert mountains, the Taliban were waiting for the right moment to launch a major attack. Suddenly, rockets came flying right by us. We had to retreat. On the road, we passed young resistance fighters, with faces grown old, who were going up to defend the position. They were walking up to hell.

Massoud had just given some coded instructions for an offensive he was planning against the Taliban, and was now reading. As I arrived, he was deep into a collection of poems published in the Panjshir Valley, *At the Dawn of Hope.* In the quiet of that Ramadan night, our poetry reading and verbal jousting helped us forget the cruelty of battle. A fervent defender of a peaceful and tolerant Islam, he had been waging his guerrilla campaign to free his country for close to 20 years. Beyond the harshness of his life as a fighter, Massoud had a sweetness about him, and radiated humanity and a deep inner joy.

A letter to Massoud, the bearer of light. You were killed, blown up by a bomb. Not long before your death was announced, a death we all dreaded, you said to your son, Ahmad, in front of your relatives, "If I am to die for the ideals I have defended all my life, I don't want you to cry or to let your heart tremble." But how can we not be overwhelmed with sadness when a man of truth is assassinated? + In this world in which selfishness and perversion, economic interests and power conflicts are all mingled together, there seems to be little room for the bearers of light. They upset the established order, or rather, the "disorder," of the world. Didn't Socrates and Gandhi die in the name of a truth that went against the darkness of obscurantism? + The son of a rich, little-appreciated culture, you belonged to that small number of people who, at the risk of awakening the animosity of the established powers, place their actions and thoughts at the service of humanity. + A poet by nature, you were forced to wear the disguise of a war chief in order to drive back the Russian Army, which had come to crush your people under its boot, to the detriment of your country's independence. + You were the one who was able to fight against the Soviet war machine, so deeply feared by the West when the Cold War was at its peak. + You were the one who shook the Berlin Wall, which had split the world in two before it tumbled down a year after the defeated Russian soldiers had left your country. As for Westerners, they were cowardly and turned their back on you. + Between a Soviet Empire at the twilight of its influence, which felt hurt and affronted by its own failure, and a Western bloc that had sold out to economic interests, you tried, alone, to do the impossible task of establishing not your power but the peace and independence of your country. + How many times did you call for help? How many times did you hear only the echo of your words, which seemed to be bouncing back from mountain walls? + Life is beautiful, my friend. I believe this deeply. One can kill a man, break his body, destroy his flesh, but one cannot kill his thoughts. + You are the noble soul who had a dream for your country and for the world: "I see a free and independent Afghanistan, a country whose people will choose its own 'Council of Wisemen'—Loya Jirga—made up of hundreds of representatives. I see a country whose government will be elected and where weapons will be laid down. I see the *mujahidin* fighters set up a 'reconstruction army' and an 'education army.' I see girls going to school, just like boys. I see our cultural and historical heritage protected and appreciated. It is our collective memory. Finally, I see all the children of Abraham living together in peace." + You went on, looking pensive. "This is what I have started to build in Panjshir. Someday I will help spread it across Afghanistan. And perhaps the world will be interested in such a model." And when I said to you, "Democracy already exists in the West with similar principles and organizations," you answered, "No, those are not real democracies. A real democracy does not help the Taliban seize power and betray its own principles in the name of economic interests. You have to imagine a true democracy in your mind and then put it into practice." + You were the light along the difficult path to peace. My friend, I truly believe life is beautiful when I see other bearers of light travel the road you have shown us. Our lives crossed paths for 16 years. I will never forget our friendship, or the games of chess we played. + Remember that old Persian proverb I quoted to you one day: "All the darkness in the world joined together cannot put out the light of one small candle."

AFGHANISTAN | *1992*

AFGHANISTAN | *2000, Panjshir Valley, Massoud's stronghold*

AFGHANISTAN | 2000

AFGHANISTAN | *2001*

By 2000, the Taliban had already been ruling most of Afghanistan for five years. Massoud's resistance army was severely tested. All he had left under his control was the Panjshir Valley and a small area in the north of Afghanistan. As he continued his fight to push out the Taliban, Massoud was working to strengthen the foundations of the ideal society he was setting up in the Panjshir. He liked to say that everyone had a role to play, telling me: "In each village, I try to have a wise, older man elected as the leader of the people's council. Those who don't have the physical strength for combat are in charge of the administrative, financial, and communication activities." Many Afghans had come to the Panjshir Valley to escape the Taliban's brutalities, swelling the number of refugees in the camps. Already overpopulated, Massoud's camps had no financial support from the UN or NGOs.

At dawn, the rays of the sun barely pierce through the thick fog that surrounds the thousands of refugee tents.

The noises of war overpower the memory. If you try to black out your visual memory, just for a moment, so you can concentrate on what you remember hearing during battle, then you become overwhelmed by a completely different perception of war, as well as by different emotions.

The list of auditory memories is long: the rustle of dead leaves stepped on by panting fighters as they run; the heavy crunching of the snow as refugees trudge past on their way to exile; the whistling of bullets whispering that death is near; the sounds of rocket launchers, machine guns being reloaded, planes roaring menacingly just before they drop their bombs. And the human cries are the worst sounds —they leave slashing traces in your soul, so powerfully do they evoke the suffering of human beings you passed by and heard. I will never forget the moaning I heard one night in Dasht-e-Ghala. It wasn't loud. It was a murmur and seemed to be a cross between a painful groan and a lullaby sung to a baby, but it tore through the silence of the night. The sound came from a modest house. A woman sat next to a young man, holding him in her arms, touching him tenderly. Her only son, Muhammad Abdul Halim, had been hit by a bullet during the battle. Twenty years old, he had just taken his last breath. They had a few hours left before she would have to separate from him.

She carried on her monologue all night, for him, just for him.

AFGHANISTAN | *2001*

AFGHANISTAN | *2001*

On November 12, 2001, thousands of men wearing brand-new uniforms are at the entrance to the Panjshir Valley, heading towards Kabul. They hold weapons in their hands and have tears in their eyes, because they are mourning the death of Massoud, their leader. The men are marching to the city in a final offensive to force the retreat of their enemy—the combined forces of the Taliban, Pakistani fighters, and al Qaeda—whom they have been fighting for over six years.

The next day, at dawn, the only Taliban and al Qaeda forces to be found lie dead, scattered along the road. The others had fled during the night, to avoid

facing the vengeful determination of Massoud's men, who are driven to carry on the fight of their recently assassinated leader.

The road to Kabul was now open. In 1992, the first time I entered Kabul, I was next to Massoud, riding on his tank into the city right after it had been liberated. On November 13, 2001, I was one of the first journalists to enter the city, which was waking up again after six years of darkness and repression. Freedom was in the air. For me, though, there remained the sadness of not being able to share this moment with Massoud.

The patriarch of three faiths. Travelers have always been welcomed generously in the Middle East, in accordance with ancient tradition. During my career as a photojournalist, I have traveled in more than a hundred countries. Nowhere, though, have I been received with more warmth than among the Bedouin nomads. Exhausted after driving for hours in the Sinai desert, when I stop and approach the tent of a Bedouin, someone immediately offers me coffee and a carpet to sit on, and I am treated like the guest of honor. Yet no one asks me who I am or where I'm from. Long ago, Abraham, the patriarch of Islam, as well as of Judaism and Christianity, established the principle of hospitality as a rule of life. When three men mysteriously appeared outside his tent, says the Bible, he brought them water to wash their feet. Waiting on them himself, he served them bread, curds and milk, and a calf that he had a servant prepare especially for them. A nomad, Abraham traveled in many lands. According to Genesis, he was born in Ur of the Chaldees—the present-day Iraqi site of Tall Al-Muqayyar, midway between Baghdad and the head of the Persian Gulf—and went to Haran, in southeastern Turkey. From there, he made his way to the land of Canaan, an area that extended from Syria to Egypt. After a famine struck Canaan, he traveled west to Egypt, where he became a rich man. He returned to Canaan, and died and was buried in Hebron, not far from Jerusalem.

EGYPT | *2000*

The world was about to enter a new millennium. In a time marked by divisions, *National Geographic* magazine decided to do a story on Abraham, the founding father of the three monotheistic religions— Judaism, Christianity, and Islam—and his descend- ants. On the eve of the year 2000, I was in Turkey, in the historic city of Sanliurfa, known as Urfa until World War I. Once also called Ur, it is closely linked to Abraham. Some claim it was his birthplace, rather than Ur of the Chaldees, pointing out that it is much nearer to Haran, where he is said to have traveled. Muslim pilgrims come to worship at the supposed place of his birth, a cave in the southern part of the city. Two pools, stocked with carp, lie near the cave. According to legend, King Nimrod, furious at Abraham for preaching his monotheistic faith, had him sentenced to death. Abraham was flung into a fire. All of a sudden, a huge pool of water appeared, and the scorching logs turned into fish, saving his life. The two pools, whose schools of carp are considered sacred, were built to represent this miracle.

On December 31, everything in Sanliurfa was serene and impervious to the upcoming change of millennium. As I puzzled over the city's calm, one of the residents told me, smiling, "We have 9,000 years of history. The new millennium is a thing for young countries."

ISRAEL | 2000

ISRAEL | *2000*

Opposite: According to Genesis, the angel Gabriel appeared to Abraham, telling him to sacrifice his son as a sign of submission to God. Muslims believe the boy was Ishmael, his son with Hagar, an Egyptian slave, whereas Jews and Christians think the boy was Isaac, his son with his wife, Sarah. Despite the temptations of Satan, Abraham carried his son to the site for sacrifice, ready to obey God's wishes. The location for the sacrifice depends on the believer. For the Samaritan Israelites, Abraham took the boy to Mount Gerizim, in Nablus. For mainstream Jews and Christians, the place was the Temple Mount in Jerusalem. And for the Muslims, the sacrifice was to occur on a hill east of Mecca.

At the very moment when Abraham was about to cut the boy's throat, Gabriel once again appeared to him. The angel held a ram intended to take the child's place as the sacrifice. Abraham, put to the test, had proved his submission to God.

In commemoration, Muslims sacrifice sheep every year during the festival of Eid Al-Adha. On Mount Gerizim, I took this photograph of the Samaritans sacrificing sheep on the eve of Passover.

Above: During the long months I spent covering the story on Abraham, I traveled to Israel, Palestine, Egypt, Saudi Arabia, and Turkey, following Abraham's footsteps while on my own spiritual quest. I attended religious ceremonies for the three monotheistic faiths. For an instant, during these rites, I felt as if I belonged to all those religious communities.

During the Easter celebration in Old Town Jerusalem, a procession to the Church of the Holy Sepulchre honors Jesus' painful Way of the Cross, inspiring fervor in devout Christians. During the slow march, the rhythmical hymns echoed through me, like the sound of a shofar, the ram's horn that helped the Jews capture Jericho. The music also brought to my mind the prayers I had heard pilgrims say softly as they circled the Ka'aba in Mecca.

ISRAEL | *2000*

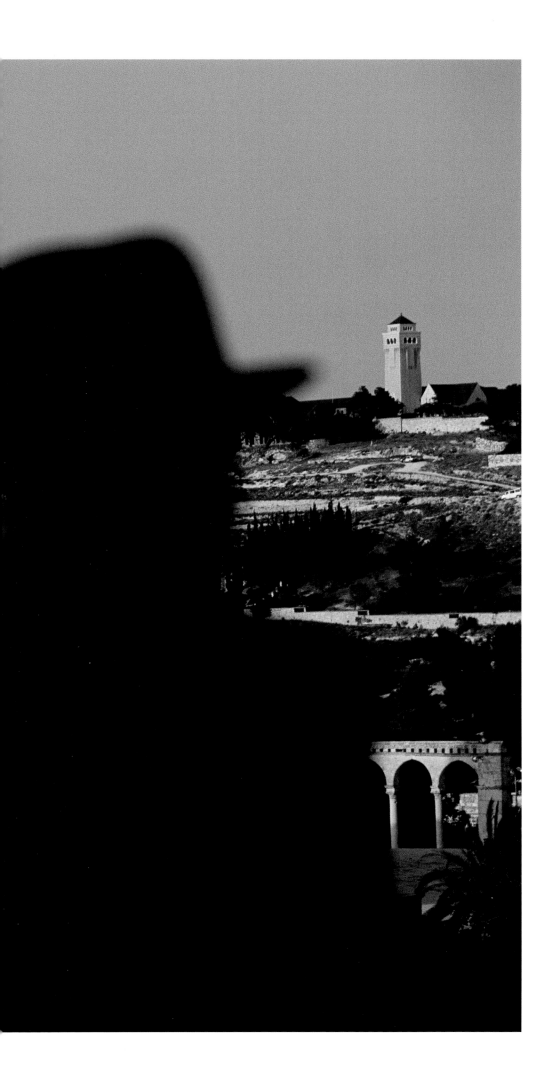

Under the golden dome, there is a venerated rock. The Dome of the Rock houses the tip of Mount Moriah, the object of covetousness and strife. For Jews, this marks the site where Abraham came to sacrifice his son, and where Solomon and Herod built their temples. For the Muslims, the sacred rock was the place from which the Prophet Muhammad, riding on a white horse, flew to God.

In the name of this visceral attachment to a symbolic place, man is capable of sacrificing everything, even his own life.

SAUDI ARABIA | *2000, pilgrims around the Masjid al-Haram mosque in Mecca*

In an alley of Jerusalem, some Palestinian men are coming to the esplanade of mosques for Friday prayers. Israeli soldiers guard the entrances to the esplanade. They allow entry only to those who are 40 years of age or older. The younger men, filled with frustration, throw stones at the soldiers. Suddenly, a number of the men who seem to be Palestinians grab some of the youths. They hand them over to the soldiers, and then disappear. They are Israelis who volunteered to infiltrate the Palestinians for several months, imitating their way of walking, their mannerisms, their accent, their behavior. The trusted friend of yesterday becomes the foe of today.

It is written that when Abraham returned from Egypt, he arrived about 15 miles east of Jerusalem. He was traveling with his nephew, Lot. On a hill looking down on the Valley of Jordan, they found a paradise, where the water appeared sweet and the earth fertile. Abraham had grown rich. His clan included slaves, soldiers, members of his tribe, and herds of animals. Lot had only a few beasts and a much smaller tribe than his uncle. A dispute over land arose among the herdsmen of the two clans.

Abraham realized that the land was not big enough for both clans. He decided not to fight over the land. He turned to Lot and said, "It is up to you, Lot. Choose where you want to settle with your clan. I will take the place that you do not want." Lot chose to settle down in the well-watered plain of the Jordan River, while Abraham decided to remain in the desert area of central Canaan.

By allowing Lot to decide, Abraham became known thereafter as a peacemaker.

This bullfight in France evokes memories of war. Wars have marked my soul with the sight of cities besieged by the enemy. From Sarajevo to Kabul, from Sanandaj to Beirut or Gaza, I carry within me the painful memory of seeing their citizens caught in a trap.

FRANCE | *2000*

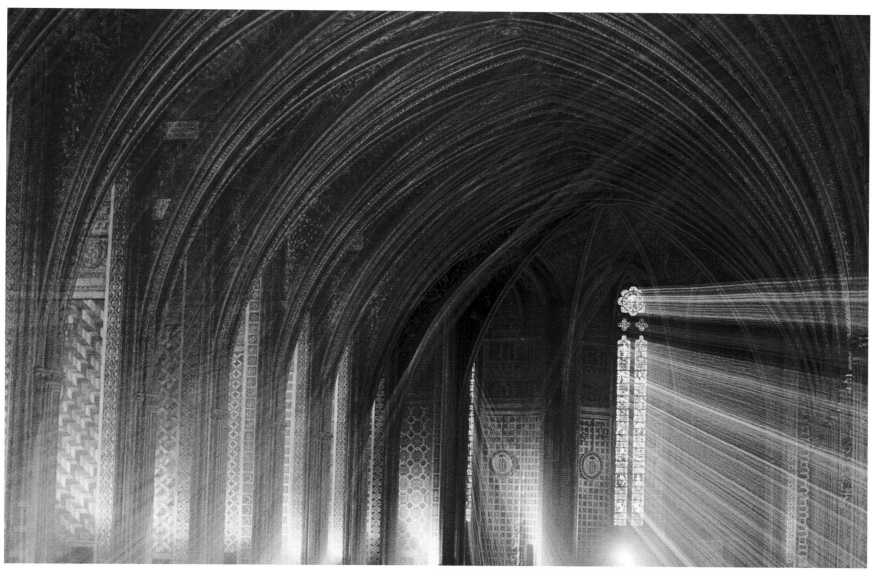

FRANCE | *2000*

During my wanderings in southern France, I traveled from village to village, seeking to discover the deep, authentic spirit of the country. The trip brought back memories of my first photo assignments around Iran, when I was barely out of my teens. Then, I was taking photographs of a country in upheaval. Almost 30 years later, as I made my way through the south of France, the time passed slowly and peacefully. This quiet interlude in my life seemed to me a gift. I was taking photographs of churches and holy sites, from Lourdes, fervent with pilgrims, to the magnificent cathedral at Albi. Houses of God, no matter the religion, create a space that nourishes spiritual serenity.

I opened the doors of the cathedral at Albi. For a moment, a divine light swept before me, filling the apse. It was a time to pause, to breathe.

France is the country that welcomed me in my exile. It is my home port in my travels as a nomad. What some call the vagaries of life and others call destiny has led me to this country. I could have set down my suitcases elsewhere. I have done it, sometimes even with pleasure. But I have always come back to France. The relationship of an exile with his country of asylum is complex, between hatred and deep attachment. In 1989, I felt more resentment than happiness about living in France, so I decided to go live elsewhere. But another turn of fate changed my life. I met Rachel, who became the sustaining link to my adoptive country. Yet my relationship with France didn't become any easier. Will it ever? Is it possible to find true inner peace when a part of yourself yearns to find again the odors, the landscapes, the images, and the rituals of your childhood?

On this summer day in 2000, more than a decade had passed since I had met Rachel. We were traveling through Provence, which I had discovered and loved when I was still in Iran, through reproductions of van Gogh's paintings.

On the arid land of the Camargue, Rachel, born in Provence, was serenely picking her favorite flower, sea lavender. Even when it is torn from the soil, it seems to keep on blooming, defying place and time.

In our home, a bouquet of sea lavender brings to my mind the delicate and ineffable message evoked by the flower.

A fragile tower of babel. The pilgrimage sites of the world's great religions are profoundly moving places, not because of their rituals but because of the serenity that radiates from the believers as they pray. Absorbed in their private communication with their deity, they look peaceful, open, and trusting. Such fervor is quite different from militant religious fanaticism, and when the ineffable bond with God is expressed in this tranquil and receptive manner, it erases every distinction of social class, skin color, or national origin. But at the holy sites of Arabia, oil has made such differences more pronounced. Millions of pilgrims come from around the world to the Muslim holy land to worship God and his prophet. Poor but hospitable, the local tribes of yesteryear withstood all types of desert storms and, for centuries, survived thanks to the pilgrims' offerings. The noble lords of the desert, who once had simple wants, have grown enormously rich from the black gold that lay beneath their bare feet. Today, they hold on tight to their riches, and the gap in wealth between them and the menial workers they employ is striking.

The princes of Arabia and of some of the gulf countries seem to have forgotten an important legend. Now focused on material goods, they want to erect ever-higher buildings, gripped by the desire to have the tallest skyscraper. For the construction, they use laborers who have come to Arabia from the world over and speak a variety of tongues. But the legend shows that a Tower of Babel will not endure the test of time.

SAUDI ARABIA | *2003, Hajj pilgrimage at Masjid al–Haram Mosque in Mecca*

SAUDI ARABIA | *2003*

SAUDI ARABIA | *2003*

Opposite: Prince Mash'al, a brother of King Abdullah, brandishes his saber to announce the opening of the saber dance. An ancestral tradition, the saber dance provides an occasion for the nomadic Saudi Bedouin to come together. On this day, tribe members and camel drivers from the entire Arabian Peninsula, as well as from the gulf, have gathered in the desert to take part in the yearly camel beauty pageant, when they choose the most beautiful female camel and crown her Miss Camel.

Above: Prince Sultan, the half-brother of King Abdullah and the second most powerful man in the kingdom, is wildly passionate about the horses he collects. I had been invited to visit one of his stud farms near Riyadh. The horses parading in front of us were magnificent. Two things struck me. The men who displayed and groomed the horses were dressed in pure Saudi style, right up to their headdresses, but they were Filipinos, Indians, and Bengalis—there was no sign of a single Saudi doing that kind of work. The second thing that amazed me was a comment I heard. Interested in the horse I was photographing, one of the prince's advisers turned to me and said, "You know, that horse is worth a million dollars." Noticing my astonishment, he added, "We have more than a hundred of them."

The members of the mighty Al Saud clan built their empire on the gold that gushes from the sunburned desert. Establishing their rule over one of the most hostile parts of the world, they took power thanks to their sharp-bladed sabers and the assistance of the British, and then the Americans. The clan is made up of princes descended from Bedouin nomads, whose fortunes changed one day when they were touched by fate—or, in Arabic, *maktub,* which means "it is written." The discovery of oil gave them riches and influence, transforming them into the region's most powerful group. The clan's 40,000 princes run the government. Organized as a hierarchy, they extend their reach over the entire country, from the private to the public sphere, thus holding all the keys to the kingdom's wealth and power. Each prince receives a huge monthly allowance, and all of the princes enjoy special benefits and are protected by the laws. I remember the words of one of these princes: "We have the same relationship with the dollar as Western children have with Monopoly money." The clout of the Al Saud clan attracts many Western consultants, a large majority of whom provide advice in order to secure oil, construction, or arms deals.

Drawn by the dazzling opulence of the oil states, several million men and women have come to Saudi Arabia and the Persian Gulf for work. They are from the West, Asia, Africa, and every part of the world. The Westerners are enticed by the easy money they can make from contract assignments, which offer fabulous pay, and they live in unequaled comfort. But the people who are from poorer regions and have fewer skills have to take work as manual laborers. They earn meager wages, which they send back home to help their relatives. For these workers, the money they can make from menial jobs here represents their gateway to a material paradise. They dig canals, lay down roads through the desert, build palaces and improbably tall luxury high-rises made of marble—whose every slab of marble is worth, in its weight in silver, as much as each one of these men weighs. Although they came to the area to improve their economic circumstances, their lives are just as destitute as if they had stayed in their own countries. Surrounded by splendor, they share filthy quarters with other workers, their companions in misery. Many of them are also trapped in these countries; on arrival, they had their passports taken by the bosses who hired them, so they are in limbo, citizens of a zone where the law is not the same for everyone. Ninety percent of the country's industry, however, depends on these manual laborers. They are called guest workers but might be better called modern-day indentured servants.

SAUDI ARABIA | *2000*

SAUDI ARABIA | *2003*

For Him, she walked for a long time to reach the spring. Then she drew from the spring's scarce supply of water enough to fill a jar. She will use the water to wash the white, dry dust from her body. For Him, she carried the heavy jar all the way back to her village, bearing her load lightly. At home, she took off her tattered clothes, folding them neatly for tomorrow and the rest of the week. She will wear them again after her return from the local mosque. For Him, she washed and purified herself. She took her spotless new scarf. She wrapped it around herself. She felt beautiful and protected. She left to go to Him, guided by the joyful sounds of the worshippers who celebrated Him.

Every year, two million pilgrims from around the world gather in Mecca for the seven days of the hajj. Over the course of the year, a total of 10 million

pilgrims will come to Mecca. During the hajj, Muslims perform a ritual in strict accordance with Islamic tradition at the Ka'aba, the large black cube at the center of the holy city's Great Mosque. Muslims believe Abraham built the Ka'aba with the help of his son Ishmael. Not far from the Ka'aba, which Muslims consider the house of God, lies the sacred well of Zamzam. It is the site of another ritual that has been repeated tirelessly through the centuries. Muslims reenact the episode in the Koran in which the well was revealed to Ishmael and his mother, Hagar, Abraham's second wife, when both were near death from thirst in the middle of the desert.

During their time in Mecca, male and female pilgrims are not separated by gender. Since the female Muslims come from all over the world, they have different customs of dress. Every style of dress is tolerated, however, as long as the women respect the

Middle Eastern concept of modesty, which casts a veil of discretion over bodies and sexual feelings. For Saudi women, this tradition is pushed to the extreme. The laws allow them few freedoms. But, as in all things, only constraint is unbearable. Imagination is sometimes richer than direct reality: The penetrating looks I have received from the veiled women I have come across during my travels in the Middle East have sometimes made me travel further, in imagination, than have the women whose bodies are unveiled to all.

SAUDI ARABIA | *2003, the Shaybah oil field in the middle of the Rub al Khali Desert*

Thoughts of an exile:

The first blow is against your freedom. Being different, thinking differently, having a different skin color, religious belief, or political opinion: All are pretexts for enslavement. Yes, at the beginning, it's a government that won't or can't guarantee your freedom as a citizen. Even if the government is not actively repressive, it may cause you to lose your freedom by not protecting you. Sometimes its passivity makes it a silent accomplice in your loss of liberty.

Exodus then becomes your only option, and the only way for you to keep on living.

The first step you take as an exile is to leave your country, often at the risk of your own life. After this difficult transition, you begin the subtler process of trying to rebuild. You have found a refuge through exile. Your new country is a sanctuary where you are physically safe and have intellectual freedom. Now you have to adjust to the emotional displacement of being a stranger.

Within you remains the memory of your lost country, and you may feel disappointment in the land where you are now living, the country you thought would be your promised land.

And beyond the joy of being free, there remains, too, a feeling of mourning for your native land. This grief is always with you, below the surface, but the longing for your homeland is called up even more acutely by a tangible reminder of your country: a familiar smell, a food that tastes like a dish back home, a countryside that evokes scenes from your childhood. You feel it, as well, when you hear someone speak your language, and you hear once again the melody of your native tongue. For the exile, the joys of the present are full of the memories of the past. As you build your life in this new elsewhere—the place where you are but that is never truly home—you carry on, while always struggling with the conflict between finding inner peace in your new country and still feeling at war within yourself because you are not in your own land.

Hidden Egypt. My attachment to Egypt is inspired by my unrelenting quest to recapture the flavors of my childhood. A voice plunges me back in time. I was 10, maybe 12. I would sometimes hear peal out from the radio the voice of a woman who was singing in Arabic, playing sensually and intelligently with the lyrics, words we Persians didn't understand: It was the voice of the queen of the Arab world, Om Kalsoum. Every time I go to Egypt, I am enchanted to hear the diva's love songs still sweeping through a neighborhood or playing on the radio of a cab.

Over the previous 15 years, I had made several visits to Egypt on assignment for *National Geographic.* Each photo story gave me entry into the lives of Egyptians. Now, I was going back to do a story about the workaday Egypt, but with no Pyramids. The article's focus was to be third-class train compartments, forbidden to foreigners. When I share the daily lives of ordinary people, I get a better sense of a nation's basic beliefs. Months of negotiations were supposed to clear all the permission forms I would need. But upon my arrival in Cairo, the answer was no—no, I would not be permitted to travel third-class.

For days I ran through a maze of ministries, asking for authorization. I had to be patient and diplomatic, tempering persuasion with humility, and not give in to discouragement as the days passed and each meeting with an official ended with the words *"Bokra, inshallah,"* meaning, "Tomorrow, God willing." But the day finally arrived when I received the permission form.

The following pages are a visual travel diary. It recounts incidents from my travels through Egypt and evokes some of the emotions I felt while aboard the trains and on stops during my sojourn in the country.

EGYPT | *2005*

I tried to elbow my way through the third-class compartment but often had to come to a standstill, blocked by all the tightly packed travelers in the train. It was hot despite the open windows. The stench of sweat from the passengers, many of whom were returning home after a hard day of physical labor, was overpowering. People were surprised by my presence. It was an unusual event on this commuter train, filled with factory workers and bank employees who looked exhausted by their daily trip of two to three hours to get back home. A number of the passengers stopped me from taking photographs. Some of them belonged to the secret police, but others stopped me out of pride, not wanting images of their poverty to be captured. Then a man asked me, "Why are you taking pictures of us?" Speaking in the Arabic I had learned in more than 25 years of covering the Middle East, I replied, "To show the way you Egyptians live." In his eyes, and in the eyes of the passengers around us, I saw stupefaction, mixed with the fear of police retaliation. The man looked around to make sure no one in uniform was standing nearby, and then he whispered in my ear, "Bravo! Look at how the Egyptian people live. They treat us like animals."

Far removed from the Egypt of the pharaohs and the tourism associated with it, most Egyptians suffer from extreme poverty, which is largely ignored by the well-off. In 1981, a state of emergency was declared which continues today. The country is sinking deeper into destitution, and the economic contradictions in its society are increasing. With each visit, I have seen the gap widen between the tourists, who have money to spend and are eager for adventure, and the Egyptians. Tourism is the basis of the economy today, and the Egyptians are aware of the benefits tourists bring to their country. But the differences in culture and wealth have led to animosity. Setting out to discover another culture is not about learning its language or customs. It is, above all, about learning humility, which permits us to open our minds to differences and to respect them, even though we may not always understand them. Remaining true to yourself, while at the same time seeking compromise, allows mutual tolerance to develop.

We live in the communication age. Every day, the other end of the Earth becomes more accessible to us, making us think that the world is one big village. But from what I have seen, people cling to their own traditions, and are becoming ever more rigidly intolerant of "the other." Each time I travel to Egypt, I am more and more surprised by the rising number of women and girls who wear the veil. In 1991, it was a far rarer sight. While the tourists, in their casual outfits, exhibit a total lack of self-consciousness, the Egyptian people seem to be going back to their traditional, covered-up style of dress, using their clothing as a means to display and assert their identity.

In Egypt, traveling by train is an ideal way to meet ordinary people. Thrust into an enclosed, self-contained universe, train passengers live a life in parentheses for a few hours. Spending time together in such close quarters, they have to be cordial to one another. The intimacy leads to trust and confidence. The train between Cairo and Aswan, in southern Egypt, became my second home while I covered this story.

One time on this train, I noticed a student who had remained silent since the beginning of the trip. Sullen and harsh-eyed, he held himself apart from the other passengers by staring fixedly out the window at the passing landscape. Cairo's endless suburbs were far behind us. Scowling, he was like an unapproachable fortress. Suddenly, an old man started talking about the cost of living, the changing world, and the upcoming elections. Then he asked me, "What about you? What do you do?" I told him I was working on a story about the Egyptian people for an American magazine. The young man broke in. With an intense anger that took everyone aback, he started to rail about Iraq and the fate of the Palestinians. "We Arabs are being humiliated by the West and by Israel, which want to lecture us on democracy and peace through violence and terror." He took out a binder, opened it, and showed me some pages with pictures he had pasted into it of prisoners at Abu Ghraib. He showed me the photograph of a Palestinian child named Mohammad, who, he said, had been killed before his father's eyes. Then he sank back into his stubborn, hate-filled silence. The atmosphere had changed and grown tense. The young man's vehemence found a certain echo among the other travelers, and I felt isolated.

After arriving in Aswan, I found a car to go to Luxor. Sugarcane fields lined the Nile as far as the eye could see. Scores of farmhands, scattered throughout the fields, worked without stop. I decided to spend several days photographing them as they worked.

From dawn to sunset, they labored in the fields, working crouched over. Their movements seemed mechanical and lifeless, as if they were automatons overcome by the heat and the arduousness of their work. I was stunned to discover that many of the young men and women weren't peasants. They had completed their university studies and had graduated. But they had no choice but to work in a factory or in a field, earning low wages. Their words betrayed their enormous sense of injustice, tinged with a growing anxiety that their future might be far different from the one they had imagined when they started out on their studies.

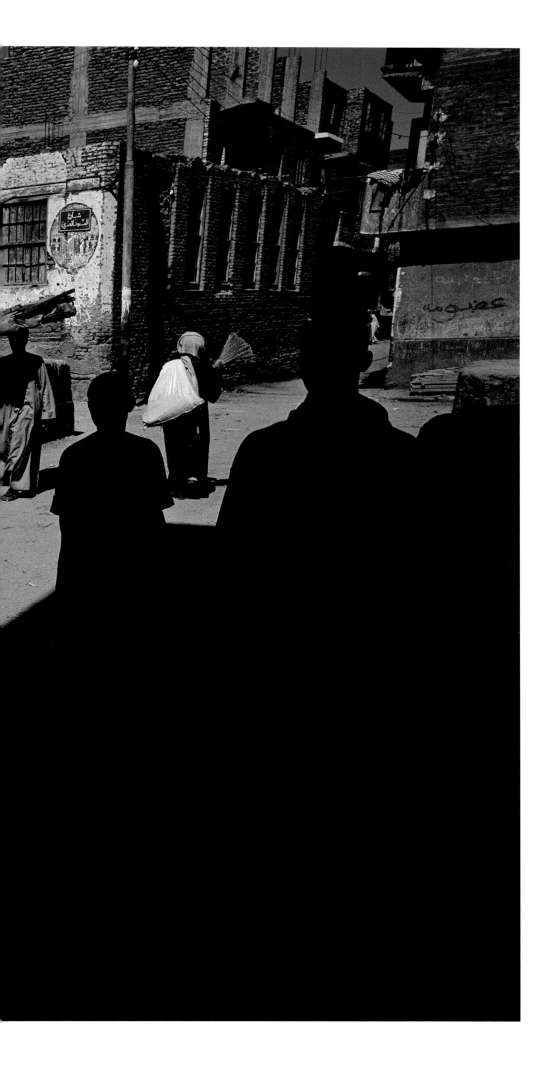

It was in one of these very streets in Cairo that an ordinary Egyptian student blew up a homemade bomb on April 7, 2005. The bomb killed several people. It was a fatal deed perpetrated by an amateur on behalf of a small, obscure group that did not belong to any extremist organization. The student had lived in one of the city's poorest neighborhoods, and had grown up on "Sewer Street" in the Shobra district of Cairo. The attack was followed by a couple of others, the last one conducted by two young girls, a first for Egypt.

Only by making steady, concrete progress toward democracy might it be possible to avoid a further eruption of violence. In 2005, Egypt held its first democratic elections since 1981. The elections gave reason for hope, but their credibility was undermined by allegations of harassment of opposition parties. President since 1981, Hosni Mubarak was elected for a fifth term.

I thought of the fall of the shah, which I had witnessed. History teaches us lessons we often ignore. The shah disregarded the concerns of his people. He failed to value traditions or freedom of speech. He deferred to foreign powers instead of protecting Iran's national interests, and he enforced the repression of every act of protest. The shah's mistakes pushed the Iranian people to demand dramatic changes. Their "yea" vote in favor of Khomeini was a "nay" vote against the shah.

I had spent several hours in the Citadel that towers above Cairo. The sun was setting. I walked along the huge alleyway that separates the impressive mosques of Sultan Hussan and Al-Rifai. The wind picked up, pushing me to walk faster. Entire families were there. Children were playing against the huge mosque walls. The wind carried the sound of a cheerful tune; a band was playing to accompany a newlywed couple. The muezzin called the faithful to prayer, and the thousand minarets of Cairo echoed. The sun slipped past the horizon. I walked toward the heart of the city. The mosque to my right was named after Rifai, a saint who had lived in great poverty.

I entered the sanctuary. Pilgrims had come to pay him tribute, beseech his help, and pray by his remains. Men, women, and children, mainly the common people, had come to celebrate the saint's deeds. I spoke with some of the believers and with the caretaker of the sanctuary. He told me, "You are from Iran. Come, I will show you the shah's grave." He led me to a tombstone in a dark, isolated corner of the mosque. It read: "His Imperial Majesty, Mohammad Reza Pahlavi." Like the six other kings buried in this mosque, he rests far from the splendor he once knew.

The pilgrims in the mosque that day walked by, unaware that they were passing by the shah's grave as they went to the tomb of Saint Rifai, a man who was destitute but rich in spirit. Standing in that sad place, silent because of the pilgrims' indifference to the shah, I reflected on my years in prison, the months of torture, and my determination that I must pursue, even as an exile, the fight for freedom of speech.

1980	IRAN
	ITALY
1981	FRANCE
1982	LEBANON
	LIBYA
	TURKEY
1983	AFGHANISTAN
	PAKISTAN
	ALGERIA
	INDIA
1984	LEBANON
	TUNISIA
	YEMEN
	GUINEA
1985	AFGHANISTAN
	JORDAN
1986	PAKISTAN
	PHILIPPINES
1987	CHINA
	SINGAPORE
	UNITED ARAB EMIRATES
	INDIA
	SOVIET UNION
	AZERBAIJAN
1988	ISRAEL
	PALESTINE
1989	SOMALIA
	SUDAN
1990	AFGHANISTAN
	UZBEKISTAN
	TAJIKISTAN
	AZERBAIJAN
	RUSSIA
1991	EGYPT
1992	RWANDA
1993	TURKEY
	CONGO
	ETHIOPIA
	KURDISTAN
	SOMALIA
1994	RWANDA GENOCIDE
	CHINA
1995	CHINA
	RWANDA
	BURUNDI
1996	CAMBODIA
	EGYPT
	ZAIRE
1997	AZERBAIJAN
	RUSSIA
	KAZAKHSTAN
	TURKMENISTAN
1998	AFGHANISTAN
	MOROCCO
	BANGLADESH
1999	RUSSIA
	CHINA
	KURDISTAN
	TURKEY
2000	AFGHANISTAN
	TAJIKISTAN
	ISRAEL
2000	EGYPT
	LIBYA
	SAUDI ARABIA
2001	SYRIA
	AFGHANISTAN
	TAJIKISTAN
2002	SAUDI ARABIA
	CHINA
2003	SAUDI ARABIA
2004	AFGHANISTAN
	INDIA
2005	EGYPT
	AFGHANISTAN
2006	**PAKISTAN**
	EGYPT
	MOROCCO
	SRI LANKA
2007	AFGHANISTAN
	AZERBAIJAN
	TURKMENISTAN
	JORDAN
2008	ISRAEL
	PALESTINE
	INDIA
	AFGHANISTAN

A search for identity. The city of Lahore lies on the border between India and the young nation of Pakistan, whose name means "Land of the Pure." The city was once a stopping place for travelers who crossed the Indian subcontinent. During their journey through this vast territory, those travelers of yesteryear encountered all sorts of religions, beliefs, and tribes. The tribes had become settled in the area over the centuries and had learned to live together as part of a huge national entity.

During his constant, peaceful struggle for the independence of India, Mohandas Gandhi no doubt dreamed of maintaining all of the country's borders as they were constituted at that time. But often warlords and religions separate people. In the case of Pakistan, the strife between Muslims and Hindus, abetted by the British colonialists, led to violence and massacre. Pakistan was created as an Islamic state after the partition of India. The borders drawn up by the departing British colonists, who were engaging in political gamesmanship, crushed any hope for a possible unity. And ever since then, recurring conflicts and perpetual animosity have set both countries against each other. After 60 years of existence, Pakistan has yet to find a unified national identity.

In a Sufi shrine of Lahore, a Sufi man catches my attention with his eyes. He was one of the followers of Rumi, the 13th-century Persian mystic who advocated tolerance and whose works provide a bond among peoples.

Well known throughout Pakistan for its religious fund-
amentalism, the city of Multan has numerous Koranic
schools of the Deobandi persuasion, whose powerful
network stretches all the way to India.

In 1979, Pakistan had 27 registered Koranic
schools. Today, the number of such schools has grown
to approximately 54,000. This increase was largely
caused by the interplay of international political forces.
Pakistan's successive governments had not invested
enough in education. The country's failing educational
system could not guarantee that teachers would
be present in the classroom or that students would
receive adequate schooling. Responding to this sit-
uation, parents enrolled their children in the Koranic
schools, which offered a stable supply of teachers
and a regular course of study.

The year 1979 also marked a decisive year in
the future global geopolitical balance that helped
encourage the expansion of the Koranic schools.
The world was split into Western and Eastern blocs,
and the two sides clashed in the Cold War. After the
Russians invaded Afghanistan, Pakistan became the
military and political rear base against the Communist
bloc. The Western bloc was supported by its allies in
the Arabian Peninsula.

We were just a few miles from Pakistan. Flying over the mountains of the Khyber Pass and Waziristan, I was aboard an American helicopter that was patrolling the area. Down below, the mountains of this tribal zone seemed inaccessible, mysterious, and disquieting, as well as dangerous for foreigners. An impassable barrier for numerous armies in the past, the mountains today serve as a hideout for the Taliban and al Qaeda, who are fighting against one of the most powerful armies in the world. Plunged into the past, I saw myself 25 years earlier, when the conflict between the Russians and the Afghans was in full force. I had been down in these mountains, covering the Afghan resistance fighters. I had shared their daily lives as they waged war, a battle for freedom far removed from any type of religious fanaticism. Our advance was slow and risky. Above our heads, Russian helicopters were on patrol, ready to attack. At that time, the Russians did not allow the presence of journalists. But I and other members of the press were able to stay at the side of the Afghan fighters. Today, wars are covered alongside the armies. In the eyes of the Taliban and al Qaeda fighters, we journalists now appear to be accomplices and spies working for the people they consider invaders, so they rarely permit us to join them. I looked down from the helicopter. Far below, in the middle of all those mountains, valleys, and caves, a war was being conducted without images to chronicle it.

For months, I had disguised myself as a Pashtun in order to cover the border zones between Pakistan and Afghanistan. I was taking photographs for an article, "Tracking the Ghost of bin Laden in the Land of the Pashtun," for *National Geographic* magazine. I was moving carefully in these tribal zones, which are one of the most strategic geopolitical areas of our time. Somewhere in the heart of these mountains, say the rumors, is bin Laden, the culminating point for all of these geopolitical tensions—the "eye of the storm."

A sudden, violent sandstorm kicked up. Taking shelter, the border patrol guards left their posts, abandoning their delicate mission in this sensitive hot spot.

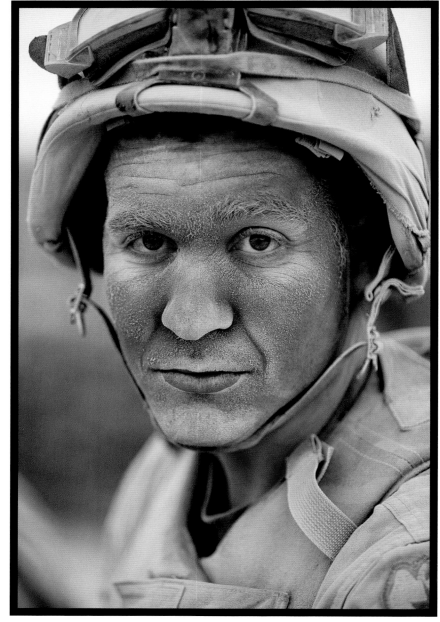

AFGHANISTAN | *2004*

Wandering in time of war. *Iran, 1981:* Dressed in military gear, the children march through the city's streets, their thin arms weighed down by their heavy weapons but their posture erect as they stride forward in their boots, a hardened look in their eyes. Separated from their mothers and fathers, they are leaving their neighborhoods far behind. Soon, their schools will only be a childhood memory. They are going to march to the front to defend their country. And if God decides to call them back to Him, they have protection — next to their hearts, they have a copy of the Koran. The government of the Islamic Republic of Iran drives them, by the hundreds, to the mine-infested swamps that separate Iran from Iraq. As they march toward the enemy fire, some mines explode. Their small bodies, torn to pieces, fall into the muddy water. And ever after, their absence fills the empty, broken lives of their mothers, who mourn their boys, the martyred children of the revolution. + *Lebanon, 1983:* A bomb falls on the devastated city. Ambulance sirens ring out, their shrill, piercing sound punctuating the customary horrors of war. The bomb has hit a pair of twins, two small, blond boys. An ambulance heads toward them. The men in the ambulance want to open a clear passage in the road, so they can rush to the boys' rescue, hurrying to give them one last chance. The men shout at the cars in front of them. They yell at the drivers to pull to the side, their screams full of anger and despair. They reach the boys, but they have only one stretcher for these two brothers, who look alike. Each boy is a mirror of the other's joys, the other's wounds, the other's frail, young body. Both of their bodies are covered in blood. Their wide-eyed stares communicate how little they understand of what is happening. The twins do not seem to be in pain yet, just immensely scared. Very slowly, one of the twins turns towards his brother on the stretcher, bending nearer to him. Slowly, he lies back down again, and gives up, leaving this world and his twin, his mirror throughout life. + *Afghanistan, 2000:* It is a dark, chilly night. The cold and the blackness of the sky are overwhelming and invasive. A threat seems to lurk behind every blast of wind or other twitch of nature. Some groans, weak and faraway, break the silence. The sound is like the soft moan of those who are dying, one last breath before they give up their bodies to death and release their weary souls. The small glow of a light shows the way to the source of the sound. Several people lie under a makeshift tent, their bodies mutilated and ripped apart by mines. In a corner, a boy looks serenely asleep. His face has the round contours of childhood. His weapon is near his bed, close to his head, in case he needs to grab it and defend himself once again. His mouth is slightly open, and it seems as if he is breathing. But nobody is busy tending to him. Now, his life is no longer in the hands of men. + *Afghanistan, tribal zone, 2004:* Fear knots up his stomach as he marches forward, loaded down by his heavy uniform, his high boots, and his helmet, jammed down on his head. He comes from far away, and he feels lost here. Each day, as he goes out on a search mission, he sees a procession of foreign sights: strange, unfamiliar mountains and valleys; veiled women; long-bearded men wearing robes; small, dirty children who scream "America, America" at him as he passes by. America, his America — the land of his pals, his girlfriend, his McDonald's — is very far away. He doesn't understand what the people here are saying. He shouts louder to make himself heard. He sees the fear in their eyes; sometimes, he sees contempt, hatred, too. He marches on. Following orders, he flies over dangerous, sensitive areas by helicopter and lands in new locations, where he conducts more patrols. He goes from one tribal zone to another, from one valley to another. He searches villages, caves, houses, people, always on the lookout for a terrorist, the invisible enemy of his distant homeland. + His mission done for the day, he goes back to the base. He meets up with the other soldiers in his platoon, his companions. He watches video games to kill time. He is waiting for an official letter from over there, his far-off country — the letter that will release him and permit him to go back home. + The next day, following orders once again, he goes back out into the dust of this desert country. He heads out on another search mission, his 20-year-old body worn out by the continual danger and the risk of dying.

The man sits in silence, reading the Koran. Everything is serene. He is barefoot on the prayer rug. Later in the day, worshippers will come here to pray, touching their foreheads to the rug several times. He is completely absorbed in his state of spiritual solitude. All of a sudden there is a loud noise, and he hears shouts in a language he does not know. Three men burst into the room. They are holding weapons. Overprotected, they are wearing too much gear for this peaceful setting. The men have helmets on their heads and heavy shoes on their feet. Trampling the carpets, they have barged into the sacred prayer hall without taking off their shoes. Blunt and without consideration, they start asking questions, look around warily, and spread the draperies open with the barrel of their rifles. They are no doubt looking for a ghost, because right now, right here, in this small village prayer hall, there is only one man, and he is meditating. Their intrusion breaks the spell of his dialogue with God. As they go, the foreign soldiers leave traces of mud on the prayer rug.

American GIs are waging an antiterrorism campaign on the Afghan-Pakistan border, undertaking this effort through a regular and methodical search for terrorists.

Every building is searched: every house, every shop, every makeshift structure, even every prayer hall—during these raids, not even the places of worship are spared. While on assignment in the area, I shared the lives of the American soldiers who took part in these patrols, following them for two weeks. I also spent several weeks with the local inhabitants, spending time with them in their villages or while they were out in the fields. Mutual incomprehension and culture shock are the reasons for the gap between these two groups of people, and each day this gap gets a little deeper.

PAKISTAN | *2004*

PAKISTAN | *2007*

Opposite: The shipwrecked boats in the harbor of Karachi are the object of everyone's desire, eyed for their worth as sources of metal. Once dismantled, the carcasses of the boats, their hulls gutted, are the subject of heated bargaining. After they are sold, the iron plates from the boats will make the long trip from Karachi to the remote and dangerous tribal zones near the border that separates Pakistan from Afghanistan.

Twelve Pashtun tribes have always ruled this area, where they live in self-sufficient isolation. Nevertheless, their secluded homeland is a strategic passageway, which has made it a focal point in the global geopolitical game. The members of one of these tribes are renowned as gunsmiths. In days gone by, the Darra craftsmen fashioned swords, but now they create replicas of every type of gun, reproducing even the most sophisticated of firearms with so much precision that experts are unable to tell they are copies. Manufactured in small, makeshift workshops, the guns are made using the iron plates taken from the boats. Forged and sharpened, the metal is turned

into weapons. The various military conflicts that have troubled this region since 1979, including the Russian invasion of Afghanistan, have caused the demand for arms to soar. To fulfill the orders, all hands are recruited, even the little hands of children.

Above: Covering the Pakistani Army, I was following some troops as they patrolled between Peshawar and the Afghan border near the Khyber Pass.

Since the partition of the Indian Empire and the creation of Pakistan, the Pakistani military and its secret service—called ISI, which stands for Inter-Services Intelligence—have always had a tight grip on the country, a state of affairs that thwarts any attempt at democracy.

Traveling on the ancient trade route of the Silk Road, I had just crossed the tribal zones of present-day Afghanistan. Up ahead, in the valley, stood Peshawar. A Middle Eastern city on the doorstep of India, Peshawar used to be a rest stop for travelers on the Silk Road and was a trading center for the exchange of goods between the East and the West. While I was in Peshawar, I planned to go to the Qissa Khwani Bazaar—the Bazaar of the Storytellers—to sit down and listen.

The 20th century saw the death, and then the rebirth, of Peshawar. The partition of India proved disastrous for the city, greatly reducing its influence. A provincial capital on the frontier, it remained a stronghold of the Pashtun but became a far smaller and more modest community.

The Russian invasion of Afghanistan revived the city, returning it to its past splendor. Peshawar grew into a center for official and illicit activities, drawing people from all over the world: The city was a hub for secret service operatives, arms traffickers, Afghan resistance fighters, United Nations workers, thousands of NGOs, and journalists. In addition, Peshawar became the resettlement home for millions of Afghan refugees.

Today, Peshawar is a large, wealthy modern city, surrounded by extravagant villas owned by warlords who have grown rich from the military conflicts in the area and the drug trade.

In the booths along the long alleys of the Qissa Khwani Bazaar, I saw television sets, radios, and satellite dishes. They have replaced the words of the tale-tellers of the past. All that is left of the bazaar's storytelling tradition is the name.

PAKISTAN | *2007*

PAKISTAN | *2007*

Opposite: Drug money and the money from arms trades are the two secret pillars of the global economy. The drug trade, however, is continuing to expand. Opium growing has become widespread. The cultivation of poppy plants has taken over much of the land in Afghanistan as well as in the isolated and inaccessible tribal zones of Pakistan.

Despite the strife that has disrupted this part of the world for 30 years, heroin production has never stopped. In the past few years, in fact, it has shown a sharp increase, reaching an average estimated yield of 150 tons per year.

Most of the opium is refined in small workshops on both sides of the Afghan-Pakistani border. Once the sap of the opium poppy is converted into heroin, the devastating drug finds its way into the veins of people all over the world. The drug's miserable victims include millions of addicts in Pakistan. Abandoned, alone, ravaged by the drug, haunted by withdrawal symptoms, many of them live on city streets and will die on the dirty ground of some shanty neighborhood.

Above: Before, life was simple and attuned to the seasons. The rhythm and continuity of the seasons allow fertile soil to flourish, sustaining the people who honor it. For four decades, her family had lived from the food they harvested. She was 16 and came from a family of tenant farmers. Nearly 70, her father was old but still cultivated the family's wheat field, a small plot of land passed on from generation to generation.

But then came the soldiers. In Pakistan, feudal landlords sometimes use intimidation to get tenant farmers to vacate their land. Well connected, the landlords can count on the military and the police to help them frighten the tenants. The soldiers ordered the family to move. But where could the family go? Their little house was home, and their plot of land was their mainstay. So they resisted. They clung to the little they had. They refused to leave. The men came back several times. And then the fateful night happened.

The house was surrounded by neighboring fields. Taking advantage of this isolation, and of the nighttime darkness, six men entered the house. Saying they were

the police, they conducted a search for weapons. One man then held a gun to her mother. Another pinned her young brother to the floor. One of the men raped her, while two men held her down.

The leader of the group had masked his face with a scarf. Her mother recognized his voice. He was the local police constable, who lived not far away.

Now, each day is a painful struggle as she and her family try to recover a little of their lost honor.

Attempting to find justice, they are forced to go back and forth between the police station and the courthouse, but are shut out. Unable to be heard, they also have to contend with some new defeat each day: Clues are ignored; the paperwork and the physical evidence are "lost"; the police, members of the same clan as the constable, refuse to press charges. There are thousands of similar cases. Yet rarely do these claims, filed by the few courageous lawyers willing to take them, ever make it to trial.

PAKISTAN | *2007*

I was visiting a Koranic school in the city of Multan. I had barely walked in the door when I was surprised to hear verses from the Koran recited by dozens and dozens of girls with high voices. Aged 6 to 12 years old, the girls had been enrolled in the school by their parents, who had completely lost faith in Pakistan's educational system. At this school, the girls learned the Koran, of course, but they were also taught the same general interest subjects that are provided in any other school. Here lies the pernicious strength of the religious fundamentalists: While knowing how to be attentive to the parents' needs and frustrations, offering them an alternative that can compensate for the government's failure to set up an effective school system, the fundamentalists are making sectarian religious education both widespread and necessary.

Multan is in the Punjab, a wealthier province than Baluchistan, an arid region with bare hills. Baluchistan lacks schools and a solid educational policy. But the children there are not the only ones who suffer from government inattention—the province's entire population has been abandoned by the central government. The people of Baluchistan do not receive much of the profits from the province's rich resources. Although a gas pipeline runs through their land, passing near the miserable shacks where they live, the pipeline's revenue mostly goes to the officials in the central government, the "Lords of the Punjab." The name was coined by the revered Baluchi leader Nawab Akbar Khan Bugti, a former governor and chief minister for the province. Bugti, who also served as a member of the Parliament, was assassinated in 2006 in a Pakistani air force raid because of the political demands he made on behalf of the province.

Baluchistan is known for handcrafted goods, including embroidered veils and clothes. After finishing their household chores, the women in the province get together in front of their houses and spend their time embroidering and talking.

The mystic Shahbaz Qalandar, whose name means "falcon" (Shahbaz) and "free of boundaries" (Qalandar), belonged to the ascetic Qalandar order of Sufism. A scholar, he was well versed in the works of Rumi, the 13th-century Persian poet and thinker who founded Sufism. Shahbaz Qalandar was born in Marand, near Tabriz in ancient Persia. One day, it is said, he left his small town to set off on a long journey to the east. He reached the town of Sehwan e Sharif, now part of Pakistan. At the time, Sehwan e Sharif was ruled by a tyrant who treated his people like slaves. Advocating disobedience, Shahbaz Qalandar organized a revolt. Legend has it that he sent a message to the tyrant, telling him: "If you do not become a righteous man, I will annihilate your existence"—a message that made the tyrant laugh. But the very next day, the people in the town found the fortress toppled and the tyrant and his men dead. In celebration, the residents of Sehwan e Sharif danced like dervishes and sang for days and nights. The tyrant had been overthrown and his subjects liberated. Shahbaz Qalandar, the man turned "liberator," spent the rest of his life teaching Sufism, a pacifist form of Islam that puts the highest value on tolerance and friendship between peoples.

Upon his death, Shahbaz Qalandar became a saint worshipped by both Muslims and Hindus. His tomb lies near the river Sindh, also known as the Indus, in Sehwan e Sharif. The small town has become the most important pilgrimage site in the region. Pilgrims from all the surrounding countries congregate there each year for the festival that commemorates the anniversary of his death, singing and dancing to "Mast e Qalandar," a Sufi chant in his honor.

PAKISTAN | *2006, annual mourning ceremony for the Sufi saint Lal Shahbaz Qalandar*

In the short scale of a human life, the erring ways of man, the jolts of historical events, and the violence perpetrated in the name of power have a profound effect and seem inordinately important. But in comparison with the long road humanity is pursuing as it marches toward peace and perfection, they account for little. They are only stages in this evolution. Since my first encounter with social injustice in Iran, when I was a teenager, I have not stopped fulfilling my role as a witness, documenting through images the crises I have observed around the world. Often, I took these photographs while being right at the center of a country's military conflicts, cultural and political tensions, or soul-wrenching tragedy. By sharing these images, I have tried to awaken empathy and personal involvement, and also commitment, so that the viewer who sees these images will be stirred to help through humanitarian actions. I have suffered physically during some of the stories I have covered, and I have suffered emotionally because of my exile from my homeland of Iran. This suffering, though, was in the service of the mission that fate has entrusted to me and that I carry out with joy. I am not drawing any sad and hopeless conclusions about humankind, which, despite the passage of several millennia, is still only taking its first, faltering steps. Over the past decades, in the intimate inner journey I have made while reporting on troubled areas around the world, I have always granted a significant place to poetry, which gives me a different reading on life. Poetry, especially the works of Rumi, helps me remain calm despite the sorrow I have seen. Without a doubt, it was Rumi who managed to anchor within me that inner peace. Thanks to his verses, the realization now dwells in me that, though we are tiny particles in the universe, we must still consciously "be"—aware, sharing, and engaged.

CLOCKWISE FROM TOP LEFT

PAKISTAN | *1983, In Peshawar, in May, at an Afghan refugee camp, Reza offers his first photojournalism courses to refugees.*

AFGHANISTAN | *2003, In Kabul, at the Aina media center, Afghan street children celebrate the first anniversary of* Parvaz, *the children's magazine.*

AFGHANISTAN | *2002, Women read* Malalai, *the first Afghan women's magazine published by Aina.*

AFGHANISTAN | *2002, In Kabul, a camerawoman from Aina shoots a documentary in a bakery.*

AFTERWORD

SERVING HUMANITY

I could have become an architect and built houses, skyscrapers, neighborhoods, cities, empires out of the wasteland. But I have instead chosen a life as a photojournalist, a profession in which one uses the ineffable language of photography to tell a story—in my case, without the use of words—to move people to see and denounce injustice. This is my life's commitment.

I could have been content to remain within my role as a well-known photojournalist—covering wars, disasters, and the beauty of exotic places around the world. Yes, I could have done this. But I felt inexorably drawn to contribute something beyond my photography, to put myself inside the story of the struggle for justice, rather than solely observing and photographing the story. For, in the long history of humanity, even empires eventually turn to dust. Bearing witness and taking action is the path I chose, a small step in my own fight for a better world.

What began my journey was the education I received as a child and a story that has deeply marked me. As a teenager, when I was still doing black-and-white photography, my steps took me to the fish market of the town of Bandar Abbas. There I saw, sitting on the ground, a woman whose wrinkles so marked her face and whose back was so bent under the weight of misfortune that it was impossible to tell her age. She had in front of her a few lifeless, almost rotten fish. Needless to say, with merchandise of such poor quality, she had few customers. I came closer and, timidly, I took her picture. It was one of my first works. The look of her impelled me to tell the story of her life. She was afraid and looked around in fear. She told me quickly that, every day, she came to the market to pick up the fish that had fallen to the ground or had been discarded for being of poor quality. She tried to sell them to those who were even poorer than she was. But a policeman was always watching, and the poor old woman had to give part of her meager earnings to this heartless official. I was outraged. I wrote a story about it. It was published in my first newspaper, *Parvaz,* and distributed throughout the high school. I had to tell the whole world, and in the face of such injustice, the world had to do something. At the great age of 16, this, to me, was obvious. The violent and threatening reaction of the shah's secret police made me realize that my fight against injustice would be long and difficult. But my father did not reproach me or punish me. Instead, he encouraged me to follow my convictions.

I spent many of the years that followed in prison because of the pictures I took. And after the revolution in Iran, my effort at denouncing injustice resulted in my exile. Often, in my darkest hours, I thought of the myth of Prometheus, who rebelled against Zeus. Zeus wanted to keep knowledge as an exclusive right reserved to the gods of Olympus, but Prometheus gave knowledge to human beings. Because of his disobedience, Prometheus was tortured.

After leaving Iran, I worked as a photojournalist and as a humanitarian activist. When bearing witness is not enough, when I feel that the suffering of people calls for direct action, I do not hesitate. In the 40 years since the episode at the fish market, I have tried to be both a witness and an activist. A balance between these roles is not always easy to maintain. But, I have no choice—this is the life I am compelled to lead.

It was 25 years ago that I went to Afghanistan to meet people trapped by war, a war imposed by one of the largest and most powerful armies in the world. I hid in the mountains, in the villages, in the trenches, with these men, women, and children. I discovered a wonderful country and a wonderful people. Their eyes reflected their souls and the suffering of war, flight, and famine. These people were living through not only the darkest hours of their own history, but some of the darkest hours in the history of humanity. Their suffering reminded me of so many other places

affected by war, places where I had seen the world at its cruelest—Soweto in South Africa, refugee camps in Pakistan, Rwanda, Burundi, Lebanon, Palestine, Karabakh, and Sarajevo.

In those years, in the camps, the townships, the destroyed neighborhoods, I always tried to share my photographic knowledge by providing refugees with the tools and skills to tell their stories so that they, too, could bear witness.

I did not focus only upon war, repression, and death, however, but also on those who work at solutions—the pioneers of humanitarian work, physical recovery, and reconstruction—the

INDIA | *2008*
In March, at the Pushkar Fort, a young girl named Djanan reads and dreams.

missionaries, the Red Cross, the French doctors. When cannon are silent and armies withdraw, the physical reconstruction of a country is urgently needed—an army of men and women with shovels to remove the rubble, NGOs to rebuild infrastructure, and doctors to treat the wounds of the body. But, deep inside a people are other, invisible injuries: the destruction of dignity, the wounding of the soul. These injuries reside in the deepest part of one's being and can, despite the best efforts at physical reconstruction, prevent a country from becoming whole. A culture of war breeds war, and those who have not been provided with cultural and intellectual tools will return to their only point of reference: the deafening noise of cannon and guns.

During my early humanitarian efforts, I taught photography to refugees in townships and poor neighborhoods, designed posters on the Rights of the Child, built a school for displaced Azerbaijanis, and launched a photo-tracing project in Rwanda.

In 2001, I founded Aina, an NGO whose name in Farsi means "mirror." The name references a metaphorical mirror in which people searching for an identity destroyed by war can rediscover their culture. Aina is based on the belief that a key element in rebuilding a damaged civil society is educating and empowering women and children in the use of media, communication, and information. Aina's programming began in Afghanistan in 2001, after decades of war and Taliban rule had all but crushed freedom of expression and open dialogue in the country. One of our primary goals was to contribute to the creation of a free and independent press as part of the rebuilding of a severely damaged civil society. In the past seven years, more than a thousand Afghans have been trained in photography, video, radio, press, and other forms of communication. As a result, millions of women, many of whom are illiterate, now regularly listen to the daily broadcast of Voice of Afghan Women, a radio program produced by female journalists. Millions of children throughout Afghanistan read (and reread) Afghanistan's first and only educational children's magazine, *Parvaz;* in Farsi the name means "to soar." In addition, hundreds of boys and girls have been taught the art of photography, and today they exhibit and publish their work all over the world. Aina also trained young camerawomen, so that they could bear witness to the history of Afghan women during 20 years of war; one of their documentaries, "Afghanistan Unveiled," was nominated for an Emmy Award in 2005. Through these various manners of expression, the people of Afghanistan have found new opportunities and hope for a better life.

Aina is a step on the path I began as a teenager provoked by injustice. The next step on this path is to replicate the successful programs of Afghanistan in other countries that have suffered through war, social upheaval, and natural disaster—to introduce to other parts of the developing world the concept of educating and empowering women and children in the use of media, communication, and information.

I continue to travel these roads of change and hope, a pilgrim seeking a world without borders and without war, a world in which the best of humanity blossoms and flourishes. That small candle still burns.

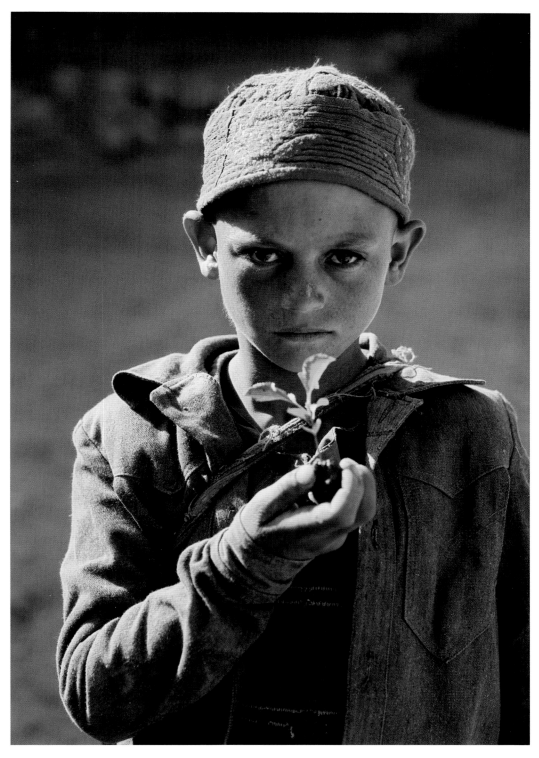

AFGHANISTAN | *1990,* *In Badakhshan, a young boy, who has come to symbolize Aina, holds a young plant.*

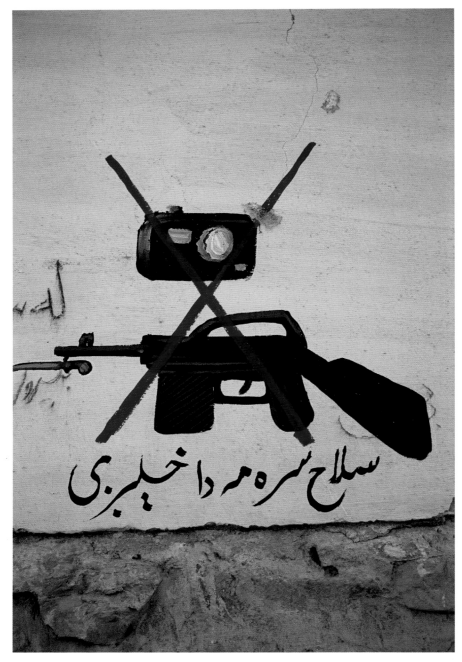

AFGHANISTAN | *2006*

Illustration credits
All images are by REZA unless otherwise noted below:
14, Gérard Rancinan; 15 LO, photographer unknown/Courtesy of the author; 18, photographer unknown/
Courtesy of the author; 292 UPLE, Philippe Flandrin; 292 UPRT, Fardin Waezi/Aina Photo; 292 LOLE, Roshanak
B./Webistan; 292 LORT, Manoocher Deghati/Courtesy of the author.

Text narrated by Reza and written in French by Rachel Deghati.

The opinions expressed in this book are the author's and not necessarily those of the
National Geographic Society.

Acknowledgments
I would like to give tribute to all the children, women and men in the world who allowed me into their lives so I might
use my camera to capture their destinies, their souls, their joy, their sorrows, and the story of their countries.
 I would like to thank my family, who have supported my commitment to humanity during the past 30 years.
 I would like to thank my friends throughout my life, and the professionals throughout my career, who have
shown me the road of quality and truth.
 Most of all, I would like to thank Leah Bendavid-Val for her willingness to make this book a reality;
Jane Menyawi for editing thousands of pictures and taking care of all aspects of the book until the last moment;
Bill Marr and David Griffin for their professional and artistic eye; Becky Lescaze, Donnali Fifield, and Hélène
Demortier for their thoughtful editing and translation work; Marianne Koszorus for her guidance and Molly
Snowberger for her creative design work; Chris Johns for his wise and journalistic advice; Nina Hoffman and
Kevin Mulroy for their professional and friendly advice; and Terry Garcia for his deep understanding of National
Geographic Society's commitment to humanity and his support. Without them, this book would not be in your
hands. All of them, more than being highly professional, have participated with great love and passion.

REZA WAR+PEACE
By Reza Deghati

Published by the National Geographic Society
John M. Fahey, Jr., President and Chief Executive Officer
Gilbert M. Grosvenor, Chairman of the Board
Tim T. Kelly, President, Global Media Group
John Q. Griffin, President, Publishing
Nina D. Hoffman, Executive Vice President;
 President, Book Publishing Group

Prepared by the Book Division
Kevin Mulroy, Senior Vice President and Publisher
Leah Bendavid-Val, Director of Photography Publishing
 and Illustrations
Marianne R. Koszorus, Director of Design
Barbara Brownell Grogan, Executive Editor
Elizabeth Newhouse, Director of Travel Publishing
Carl Mehler, Director of Maps

Staff for This Book
Jane Menyawi, Project Editor and Illustrations Editor
Rebecca Lescaze, Text Editor
Donnali Fifield, Translator and Contributing Text Editor
Bill Marr and Molly Snowberger, Design
Sven M. Dolling, Map Researcher
Mike Horenstein, Production Project Manager
Marshall Kiker, Illustrations Specialist
Jennifer A. Thornton, Managing Editor
R. Gary Colbert, Production Director

Manufacturing and Quality Management
Christopher A. Liedel, Chief Financial Officer
Phillip L. Schlosser, Vice President
Chris Brown, Technical Director
Nicole Elliott, Manager
Monika D. Lynde, Manager
Rachel Faulise, Manager
Neal Edwards, Imaging

The Book Division extends a heartfelt thanks to the Magazine Division
for supporting this project.

 Founded in 1888, the National Geographic Society is
one of the largest nonprofit scientific and educational
organizations in the world. It reaches more than
285 million people worldwide each month through
its official journal, *National Geographic,* and its four
other magazines; the National Geographic Channel; television
documentaries; radio programs; films; books; videos and DVDs; maps;
and interactive media. National Geographic has funded more than
8,000 scientific research projects and supports an education program
combating geographic illiteracy.

For more information, please call 1-800-NGS LINE
(647-5463) or write to the following address:

National Geographic Society
1145 17th Street N.W.
Washington, D.C. 20036-4688 U.S.A.

Visit us online at www.nationalgeographic.com/books

For information about special discounts for bulk purchases,
please contact National Geographic Books Special Sales:
ngspecsales@ngs.org

For rights or permissions inquiries, please contact National Geographic
Books Subsidiary Rights: ngbookrights@ngs.org

Library of Congress Cataloging-in-Publication Data
Reza, 1952-
 Reza war + peace : a photographer's journey / by Reza Deghati.
 p. cm.
 ISBN 978-1-4262-0326-8 (regular : alk. paper)—ISBN 978-1-
4262-0442-5 (deluxe : alk. paper)
 1. Photojournalism. 2. Documentary photography. 3. War
photography. 4. Reza, 1952– I. Title. II. Title: Reza war and peace.
III. Title: Reza war & peace.
 TR820.R445 2008
 779.092—dc22
 2008022906

Printed in Italy